1986

ANDY WARHOL PRINTS

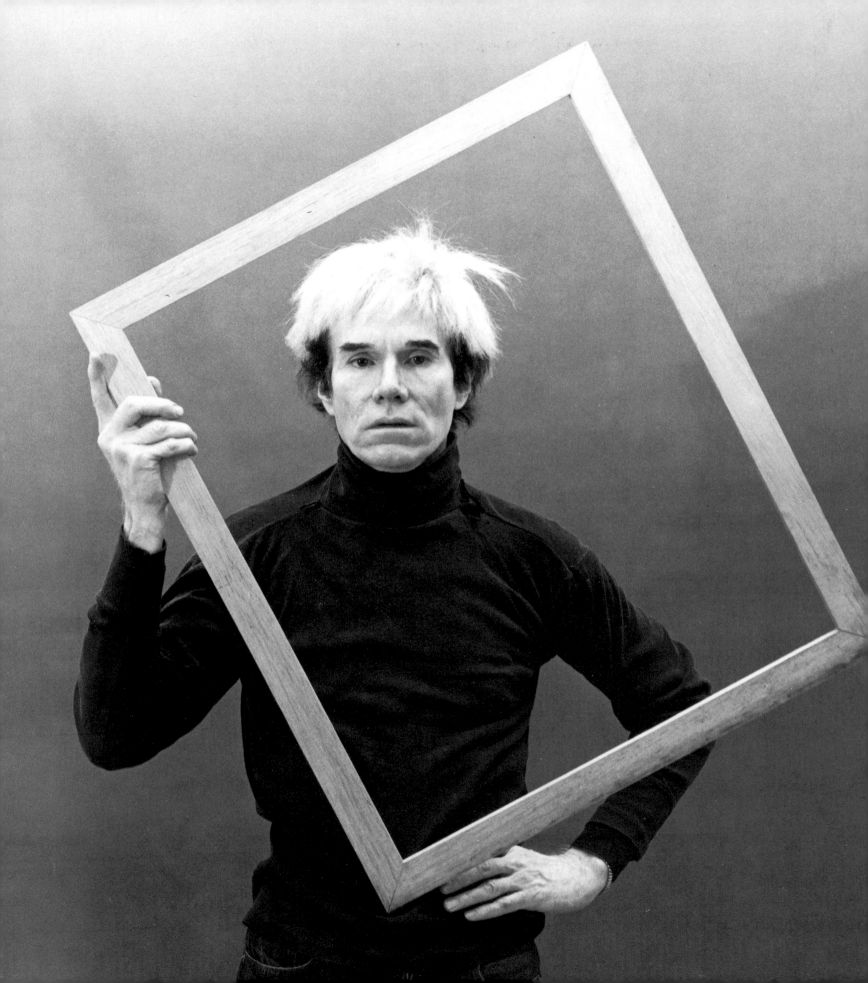

ANDY WARHOL PRINTS

A Catalogue Raisonné

Edited by Frayda Feldman and Jörg Schellmann

Ronald Feldman Fine Arts, Inc. New York

Editions Schellmann Munich/New York

Abbeville Press Publishers New York

Cover: *Details of Renaissance Paintings (Birth of Venus),* silkscreen, 1984. See page 99.
Frontispiece: Andy Warhol, 1985, photograph by Peggy Jarrell Kaplan.

Library of Congress Cataloging in Publication Data
Warhol, Andy, 1928–
 Andy Warhol prints

 Includes index.
 1. Warhol, Andy, 1928– – – Catalogs. I. Feldman, Frayda. II. Schellmann, Jörg. III. Title.
NE539.W35A4 1985 769.92'4 84-13675
ISBN 0-89659-580-3

Contents

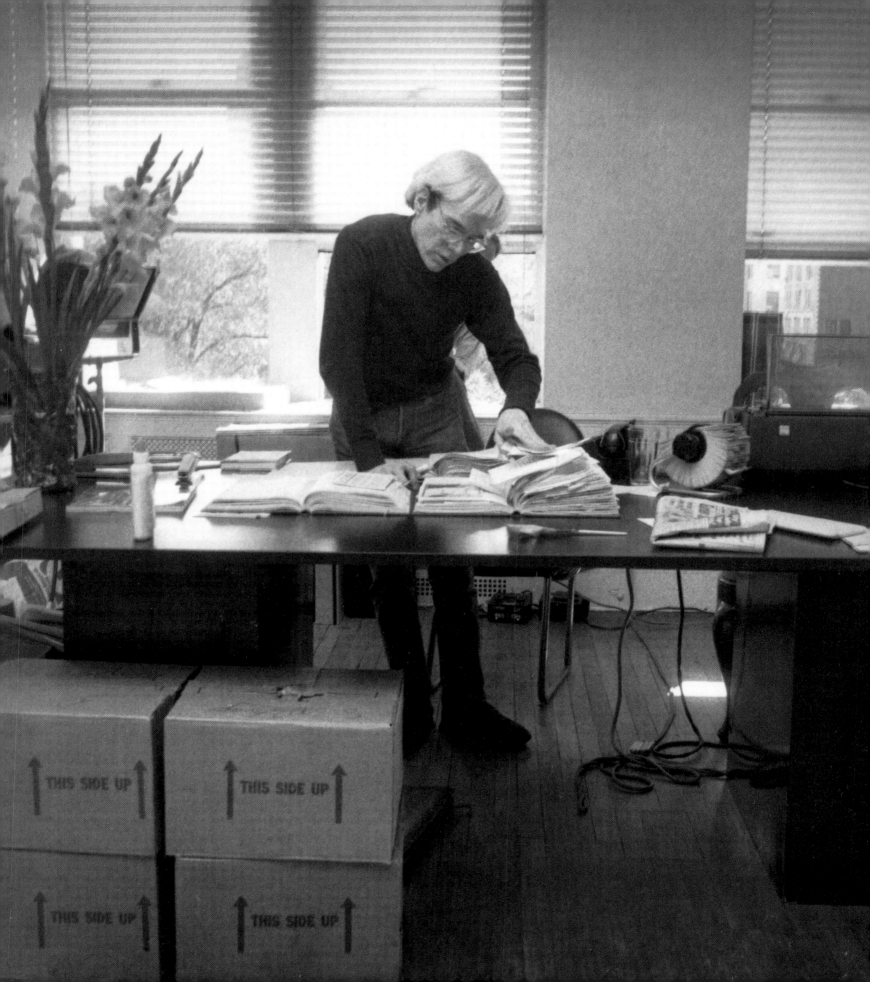

Andy Warhol's careers as a printmaker and as a painter are inextricably intertwined for the excellent reason that he employs the same silkscreen technique in both media. Warhol's technical contribution to the fine arts lies in his legitimization of the commercial silkscreen, a process which contributed an authentic "newness" to the history of picture making. While the Pop artists and their immediate forebears (Rauschenberg, Rivers and Johns) introduced novel, popular subject matter into the fine arts, it was the rightness of Warhol's images (a combination of his silkscreen's photographic literalness and the oracular power of his subjects) that helped put an end to the virtual dominance of American abstract painting and posited an entirely new set of possibilities. Every attempt made by critics, the media, or even other artists to define or domesticate this new vision was thwarted by Warhol's third contribution to art history: his personality. Through his "dumb blonde" persona, he quickly became associated in the public's mind with the new Pop movement. It is rare in our country and in our century for an artist to gain the recognition of the man in the street: Picasso, Dali, Jackson Pollock – the list is short. Even as early in his career as 1966, when I bought an air conditioner, the man who installed it in my apartment recognized a Marilyn Monroe canvas leaning against a wall. "Is that an Andy Warhol?" he asked over his shoulder.

More than any other artist in the movement, Andy set and then stretched the parameters of Pop within which all his subsequent images, ideas, written words and media activities were generated. Andy Warhol, the blank recorder; one has to look to Hollywood or the world of rock music to find sources and parallels to his monumental impenetrability. He is unique in his ability to tell all and yet maintain his kernel of inviolable privacy. "Don't understand me too quickly" might well be the motto of this most recorded and transcribed public personality.

As a classmate and friend of Philip Pearlstein, among many others at Carnegie Tech in Pittsburgh in the late forties, he moved with students whose ambitions were clearly in the fine arts. Andy came to New York upon graduating in 1949 and soon brought his mother to live with him. The practicalities of maintaining his mother and himself at barely twenty years of age, as well as the "he-man" aesthetic of abstract expressionism that ruled the day, forced a postponement but never an abandonment of his initial ambition.

It was in the commercial arts that Andy Warhol first earned his living and the attention and respect of his professional colleagues. As the 1950s wore on, he began to garner Art Directors' prizes for his shoe ads for I. Miller and his work for other clients. A group of hand-drawn, hand-colored books, made for himself and his friends in the mid-50s (the book of shoes, the book of boys, the book of cats), shows the increasing refinements of his naiveté. Meanwhile, Andy's public personality was being memorably projected in his Tiffany windows for Gene Moore (who was also employing Johns and Rauschenberg at the same time). Two of Warhol's works from this period are particularly memorable: a delightful pastel colored screen, light as air, with butterflies and angels in profusion and a real Coca-Cola bottle, gold-leafed, the latter a witty quotation from everyday life and a harbinger of his sixties oeuvre. And it was for a window display at Bonwit Teller's Fifth Avenue store that Warhol first exhibited the comic strip superhero images in the spirit and style that would soon catapult him to world attention.

When we examine Warhol's commercial work from the 1950s and his first forays into Pop in 1960, we find the artist's naive touch expressing itself through his tenuous, edgy draughtsmanship. His signature style of the period was a delicate broken line made by a simple transfer process — an early indication of the appeal the printmaking esthetic would have for him with its qualities of displacement and "at one remove."

By Warhol's own admission (and my observations at the time), it was the jolt of the authoritative statement made by Roy Lichtenstein's paintings that led Andy to abandon his nervous line and reticent coloring for the cool, clean, distant image. The result was the *Campbell's Soup Cans* of 1962 – the "Nude Descending a Staircase" of Pop art. Here was an image that became the overnight rallying point for the sympathetic and the bane of the hostile. Warhol captured the imagination of the media and public as had no other artist of his generation. Andy was Pop, and Pop was Andy.

Warhol's *Coca-Cola Bottles* (1962) and his equally celebrated and contentious sculptures of *Brillo Boxes* (1964) created worldwide recognition for this new American art, condemned as consumerist by many commentators, but enthusiastically accepted by the art public in Europe, Australia and Japan. Here were quintessential post-war American icons, the Marshall Plan made manifest. America's dual exports, culture and low-cost consumer items (Campbell's Soup, Kellogg's Corn Flakes, Heinz Catsup), were monumentalized as

ingredients of the American dream that Hollywood has so successfully projected, inspiring an almost universal familiarity and fascination with all things American. One of the first salutary surprises to the American art community was the German phrase that so accurately described one aspect of Pop's message: Capitalist Realism. But at just the moment that Warhol seemed to be deifying the common commercial object, he turned the attention of the public away from Campbell's Soup (although in fact he continued to create fugue-like variations on these themes into the middle sixties) toward a very different face of America – the *Birmingham Race Riot* (1964), *Car Crashes* (1963) and *Electric Chairs* (1967) and, unforgettably, the images of Jacqueline Kennedy in mourning, the steadfast Roman matron of ancient times presented in all her tragic dignity.

In extending the range of feelings evoked by his art, Warhol joined George Segal in making it clear that Pop art did more than mutely accept the values of America's commercial culture. It was both a celebration and a critique of those values. Thus, in the 1972 silkscreen *Vote McGovern* (#84), the anger and horror Warhol feels for Richard Nixon is sharp and unrelenting. The image of Richard Nixon is as familiar through advertising as the soup can and bears the same dead, frontal blankness. But here Nixon's face is divided into three color areas: yellow mouth, blue jowls and green upper face — loathsome colors for human flesh. The smile, as Warhol tells us through these color divisions, never reaches the eyes; this is a latter-day *Disaster* painting, a category that looms darkly over all of Warhol's work where social criticism is expressed through the choice of images and the ways in which they are cropped, centered, isolated or repeated.

In the silkscreen prints, there is, in general, a sunny, upbeat mood. In fact, only the *Birmingham Race Riot,* 1964 (#3), the *Electric Chair,* 1971 (#74–83) and *Vote McGovern,* 1972 (#84) can be construed as being negative about their subjects. In the *Endangered Species* prints (1983) (#293–302), the impact is registered through the loving monumentality conferred on each of these mute heroes and by their brilliant coloring. By isolating and highlighting the *Pine Barrens Tree Frog*, the *Orangutan* and the *Bald Eagle*, Warhol confers on them superstar status. Our horror is not at the images but at their potential absence.

The *Mao* portraits, 1972 (#90–99) and the *Hammer and Sickle,* 1977 (#161–164) can be said to escape easy categorization as positive or negative statements. The irony that is obvious and front row center in these images is

the fact that they are produced cheaply to be sold dearly by an artist in the heart of *the* capitalist capital of the world – this irony sits lightly on these superb icons. By their gnomic presence and noncommittal presentation, we are forced, once again, to inquire as to the artist's intentions. Is he being cynical? Is he kidding? Is he simple? Does he think we're simple? Are we?

There is a quality to Andy Warhol's public persona that inspires endless discussion, quite unlike that of any other artist. Such discussions inevitably center on the question of his intentions and the artist's control over the meanings in his work which are often subtle and contradictory. He has cultivated to perfection a naive blankness, a bottomless well of innocence when forced to declare himself on an issue. In a recent video interview, I asked him about the political implications lurking in the *Hammer and Sickle* and *Dollar Sign* series. "You know I don't know hard questions," he replied dead pan. The truth is that those of us who have been among his close friends for the past twenty years or more have exactly the same questions about Warhol's intent and control as does the informed public. At a party I gave in 1962 for Andy's first show in a New York gallery, Barbara Rose had referred to Andy in conversation as an "idiot savant." I later reported this to Andy who said, "What's an idiot *souvent*?" Point taken.

Andy Warhol's work consists of deeply intuitive choices by an uncannily shrewd commercial intelligence and, conversely, divinely accurate and semi-automatic dips in the dark of contemporary intellectual history. Andy has shown unfailingly his genius for finding and declaring the spirit of our times, the cherished *zeitgeist* that knows what it knows before it knows it. His work offers us a minefield of possibilities; when Italian, German and French industrialists hang his *Hammer and Sickle* in their living rooms or offices, we know something is afoot. Much as hunters have always loved to hang trophies of their conquests, the instinct is to tame and render less threatening their deepest nightmares of the forest; thus, it is possible to purchase the opposition symbol and trivialize its potency by making it an element of decoration, handsomely colored, expensive and, through repetition, less uniquely intense and formidable.

By the mid-seventies, Andy was sufficiently secure as a fine artist to quote from his own earlier drawing style – the one we associate with the aura of Jean Cocteau, butterflies and the handmade books. In the *Flowers,* 1974 (#100–119), the hesitant, nervous line is used to stunning

advantage in a meditation that is at least as much about the vases that hold the flowers as about the blossoms themselves. To reinforce the allusion to the fifties and his own books, these silkscreens are left black-and-white in one edition, and the artist exercises the playful option of coloring them by hand in another. A delicate and casual hand hovers in the air and brushes with watercolor, now this leaf, now this petal. Andy Warhol the collector is also visible in these portfolios; by the mid-seventies, the Art Deco revival was in full swing. For half a dozen years previously, Andy collected the best of French art glass, and it is just this fascination with shapes and textures that provides the special charm of these silkscreens.

One fascinating aspect of Warhol's merging of the commercial world with that of the fine arts is his uncanny ability to work to "measure" – to meet the occasion with an unpredictable but, after the fact, exact and apt image that suits the specific event yet lives beyond it. It is in this spirit that we can come to understand the best of his commissioned prints and portraits. Indeed, much of Warhol's work in recent years has been commissioned and tailored to specific locales and audiences; e. g. *Beuys* (#242–247), *Goethe* (#270–273), *Ingrid Bergman* (#313–315), *Kiku* (#307–309), *Love* (#310–312) and *Reigning Queens* (#334–349) for publishers in Germany, Sweden, Japan and The Netherlands ; *Alexander the Great* (#291–292) to coincide with the Greek government loan show at the Metropolitan Museum; *Brooklyn Bridge* (#290) for the Centennial celebration. *Ten Portraits of Jews of the Twentieth Century* (#226–235), *Myths* (#258–267), *Endangered Species* (#293–302), *Details of Renaissance Paintings* (#316–327) and *Ads* (#350–359) are other kinds of print projects Andy has turned to in recent years with wonderful tact and vigor. It is almost as if Warhol works best under the pressure of an assignment – a holdover from the days of magazine layout deadlines.

As with all artists who produce large bodies of work, distinctions can be made only after a time as to what is major and unforgettable and, conversely, what is theatrical and ephemeral. Andy surprises; lightning strikes unexpectedly, and an image is permanently illuminated in our memory. These moments occur at every stage in his career.

Andy Warhol's importance lies in his ability to recognize the qualities of ordinariness and to focus attention on them until they are no longer ordinary. When a genius is riveted by the ordinary, it is filtered back to us through his eyes, becoming, by definition, extraordinary.

After studying Art History at Yale, the Sorbonne and Harvard, Henry Geldzahler joined the staff of the Metropolitan Museum of Art in 1961. He became the first Curator of Twentieth Century Art in 1966, and in 1969 mounted the exhibition *New York Painting and Sculpture, 1940–1970* which inaugurated the museum's Centennial Celebration.

Having served at the Metropolitan for seventeen years, Mr. Geldzahler was appointed Commissioner of Cultural Affairs of the City of New York by Mayor Koch in 1978. In his five years as Commissioner, the city's expenditure on the arts more than doubled. Since resigning as Commissioner in December 1982, Mr. Geldzahler has been lecturing, writing, curating and advising collectors and corporations.

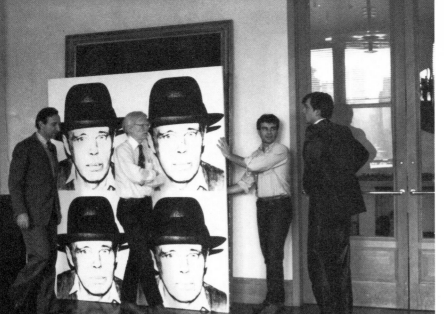

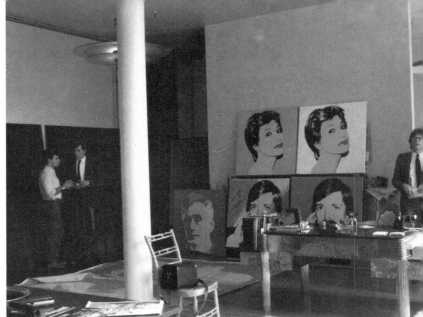

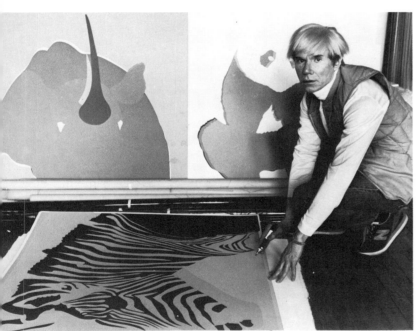

"If you want to know all about Andy Warhol, just look at the surface of my paintings and films and me, there I am. There's nothing behind it." [1]

Andy Warhol's most recent self-portrait, as *The Shadow* in *Myths*, 1981 (#267), shows him at the height of his career as an artist and art entrepreneur. Born of Czech immigrant parents in 1928, Warhol grew up in lower working class surroundings near Pittsburgh. He moved to New York in 1949 and established himself as a successful commercial artist during the 1950s. In the 1960s, he was recognized as a major Pop artist and confirmed his reputation as a leading art celebrity. Throughout his career, he has maintained the image of a perpetual seeker of the fruits of the American Dream and fan of glamorous culture heroes, while making art works that challenge the assumptions inherent in those ideals. In an earlier *Self-Portrait* from the mid-1960s (silver and black *Self-Portrait*, 1967 (#16), Warhol presents the same remote self image, with features half obscured in shadow, showing himself, the artist, as the detached observer of his surroundings. During the 1960s, when "things had to break down, so they could be put back together again in a new way," [2] Warhol's art was the cutting edge of contemporary culture and integrally linked to the changes occurring in art and society. Subsequently, his milieu has shifted from the underground to high society. Warhol, however, remains the shadow, the elusive voyeur, forever responding to the pulse of cultural change and continuing to demand attention.

"I tried doing them by hand, but I find it easier to use a screen. This way I don't have to work on my objects at all. One of my assistants or anyone else for that matter, can reproduce the design as well as I could." [3]

In the early 1960s, Warhol established the central role of printing in his art by choosing silkscreen as the medium for his works on canvas and by using mass-produced images as subjects. In his best works, technique and image coincide to focus attention on significant issues of contemporary society and to reveal the impact of mass media on cultural values. Warhol's actual use of silkscreening belies his stance of total detachment from the process: he has always been directly involved in making his art works and subverted the mechanical aspect of the medium through uneven and off-register printing. At the same time, he exploits the mechanical and commercial implications of silkscreening to challenge the uniqueness of individual easel paintings and the mystique of the artist's hand, undermining concepts inherent in Western art since

the Renaissance. His *Flowers* series from the mid-1960s, in which he produced over 900 canvases of the same image in different sizes,[4] represents his most rigorous pursuit of the idea of the reproducible painting. However, while Warhol's silkscreen paintings imply the possibility of reproducing identical images *ad infinitum*, each painting, in fact each image, is different and the numbers produced limited because of his personalized handling of the silkscreening technique. It is in his professionally printed editions of screenprints that Warhol has the means to create large numbers of truly identical images, providing the opportunity for him to employ his technique of mass-production to produce a truly democratic art: inexpensive, plentiful and available to everyone. He comes closest to achieving this goal in his large editions of prints from the mid-1960s based upon images from his paintings: *Liz* 1964 (#7), *Flowers* 1964 (#6), *Campbell's Soup Can on Shopping Bag* 1964 (#4), black and silver *Self-Portrait* 1967 (#16).

While Warhol logically takes advantage of the capacity of prints to create identical images, he also uses screenpainting to subvert the conception of a printed edition by making individual prints unique, just as he used silkscreen on canvas to make paintings appear reproducible. This occurs most often through varying colors of prints in a given edition, as in *Sunset* 1972 (#85–88) a *tour de force* of eye dazzling decoration, where each of the 632 prints in the edition is done in a different color scheme. Thus Warhol's prints add an important conceptual dimension to his work, as well as allowing him to create visual effects impossible to achieve in painting. Increasingly his printmaking activity has become more integral to his art, generating images and influencing his painting style.

Prints 1962 – 1972

"I feel I'm very much a part of my times, of my culture, as much a part of it as rockets and television."[5]

Among Warhol's earliest prints, including his first done in silkscreen, are small editions of five to eight prints on paper or plexiglas. Because they were printed by Warhol himself, they retain the hand done look and varied surface textures that characterize his early paintings and demonstrate that Warhol's initial thinking about printmaking technique was closely linked to his painting. For *The Kiss (Bela Lugosi), Cagney* and *Suicide*, Warhol chose subjects he had first, or exclusively, done on paper. For *Sleep, Empire State*

Building, Couch, Eat and *Kiss*, he used stills from his own films repeated on plexiglas to imitate the look of successive frames on a filmstrip.

In his first large edition of screenprints done for group portfolios, *Birmingham Race Riot* 1964 (#3) and *Jackie I, II and III* 1966 (#13–15), Warhol imitates the style of his paintings from the mid-1960s by printing the images in silver or black on monochrome backgrounds. He exploits the graininess of the photographic reproductions to call attention to their origin as found images taken from the mass media and to obscure their legibility in order to manipulate the viewer's response. The lack of detail in *Birmingham Race Riot* creates an initial reading of the surface as a pattern of contrasting areas of light and dark; as details come into focus, pattern coalesces into image, engaging the viewer in a disturbing document of racism in America. In the *Jackie* prints the graininess produces an out-of-focus effect that augments the portraits' tragic overtones. Warhol's *Race Riot* and *Jackies* reveal his genius for selecting highly charged photographs and presenting them so that they transcend their original function as documentary news items to become archetypal images crystalizing essential issues of American political and social history. These subjects also demonstrate how Warhol uses narrative or implied narrative to call attention to the sequence of events surrounding the moment recorded by the camera. In the *Jackies,* the narrative context adds a crucial dimension to the meaning of the image: Warhol's use of photographs taken at different times before and after the assassination of John Kennedy underscores how that event irreversibly altered the spirit of the country.

In *Flash-November 22, 1963,* 1968 (#32–43), Warhol takes up the same theme, this time in a portfolio of eleven prints conceived of as a narrative and accompanied by a text of news bulletins from the day of the assassination. Rather than illustrating the event, Warhol presents an array of images whose sequence is not as important as their ability to convey the dramatic impact of the event. In addition, Warhol's choice of photographs reinforces the importance of the media's coverage in shaping the public's response. Warhol uses several different images of Kennedy, sometimes more than one in a given frame (as in *Jackie III*), and he also uses superimposed images, a stylistic device rarely found in his work. The prints in *Flash* show Warhol's masterful ability to manipulate found images by varying their scale and clarity and using color to create powerful expressive effects through decorative surfaces, dissonant contrasts and somber monochromes.

Flash is the least known of a group of portfolios marking a more serious commitment to printmaking for Warhol and ranking among his finest works. The others, *Marilyn* 1967 (#22–31), *Campbell's Soup I* and *II* 1968–69 (#44–63), *Flowers* 1970 (#64–73), *Electric Chair* 1971 (#74–83) and *Mao Tse-Tung* 1972 (#90–99), each contain ten prints based on key Warhol images from the first phase of his career. In contrast to his earlier prints using narrative, these are static images isolated from any narrative context, each conveying a powerful iconic presence enhanced by repetition. These portfolios provide a summary of Warhol's previous handling of his major 1960s themes: portraiture, consumerism, decoration and death, themes which often overlap in a given image and continue to be central to his work.

"People are so fantastic. You can't take a bad picture." [6]

Warhol's *Marilyn* prints, like his earlier *Liz* 1964 (#7), imitate the style of his paintings of the same subject. Their multi-colored surfaces enhance the "glamorous women" image that Warhol uses for virtually every female portrait he does, where lipstick, eyeshadow and frozen camera-inspired smile are *de rigueur*. His numerous repeated images of Marilyn Monroe on canvas, done soon after her death in 1962, confirmed her role as contemporary sex goddess, packaged for the public as a consumer item. In the *Marilyn* portfolio, Warhol uses a wide range of colors (black to day-glo chartreuse) and off-register printing to show an even greater number of variations on the image than he did in his paintings. Marilyn's face is presented as an impenetrable mask, and the layers of color reflected off its surface show the mask can be manipulated to appear dazzling or sedate, frazzled or assured, glamorous or gaudy. These are typical of Warhol's portraits which are almost always about surface appearance. In the tradition of a certain style of official society portraiture, they show what the public wants or needs to project onto people who become transformed into cultural symbols: people whose "faces seem perpetually illuminated by the afterimage of a flashbulb." [7] Warhol's role as portraitist is not to represent or interpret the features of a person, but to present those features as already captured in a photograph, particularly one where the individual is recorded posing self-consciously for the camera.

"What's great about this country is that America started the tradition where the richest consumers buy essentially the same things as the poorest. You can be watching TV and see Coca-Cola, and you can know the President drinks Coke, Liz Taylor drinks Coke, and just think, you can drink Coke too." [8]

All of Warhol's art reflects his awareness of the role of consumerism in American society. The idea of the commercially promoted mass-produced product is embodied in his choice of the technique of silkscreening, and it determines his selection of subjects to include celebrities who have become cultural commodities and typical American products like Campbell's Soup, Coca-Cola and Brillo. No image is more indelibly associated with Warhol than the Campbell's soup can which became the most famous Pop art emblem of the 1960s. *Campbell's Soup Can on Shopping Bag* 1964 (#4) reinforces the idea of consumerism associated with the soup can and underscores its democratic implications both because of the large edition and original low cost of the prints and because of the lack of preciousness of the shopping bag, an object perceived as a throwaway item rather than a framable art work. *Campbell's Soup I and II* 1968 and 1969 (#44–63) reiterate the format of his painting, *32 Soup Cans* 1961-62, by using a different kind of soup for each individual image in the portfolios.

In these prints, Warhol exploits the mechanical aspect of screenprinting to such a degree that they lack any evidence of the artist's involvement and come closer than any of his other works to imitating found commercial images; in fact, they appear as though they were made for a supermarket advertising display. This machine-made look is ostensibly what Warhol was striving for in his 1962 soup can paintings. However, in comparing his early paintings or the shopping bag print with these later portfolios, it becomes obvious how diminished the impact of Warhol's art is without the handmade "mistakes" and irregularities that contradict the initial impression of identical mass-produced images. Finally what is interesting about these portfolios is the change in the labels: the first, showing the labels of the original soup cans; and the second, the fancier labels of the new soups, proving that not even the "classics" are sacred in a commercially oriented, consumer society.

"All is pretty." [9]

Warhol has consistently flaunted decoration in his art through his use of pattern and color. During the 1960s, his

repeated and serial images fit in with the minimalist's modular concept, while his use of decorator colors ignored their aversion to exuberant ornamentation. *Flowers* is the first purely decorative subject Warhol does, and with it he directly confronts the relationship between art and decoration by examining the undefined boundary between them. His cropping, flattening and abstracting of a photograph of hibiscus flowers taken from a magazine transforms the image from document to design.[10] Furthermore, the way Warhol initially displayed his *Flower* paintings, covering gallery walls to look like wallpaper, reinforced his intention to have them read as pure decoration. But while Warhol purposefully chose a pretty and exclusively ornamental motif, he counteracts its implied function as decoration by making the image too aggressive to work as conventional decoration. He further exaggerates the boldness of the image through color, as in his 1964 *Flowers* print with its garish day-glo hues conceived to clash with tasteful designer color schemes. With *Cow* 1966 (#11) Warhol takes the wallpaper idea inherent in the *Flowers* and literally makes wallpaper. By choosing a perversely nondecorative image and printing it in day-glo shocking pink and yellow, Warhol brilliantly subverts the presumed purpose of wallpaper and confronts the viewer's expectations about the role of fine art prints as framable art objects to be displayed on walls. In his portfolio of *Flowers* 1970 (#64–73), Warhol reveals his consummate skill as a colorist: the images hover between being too pretty to be art and too outrageous to be decoration and bring out the full potential of the *Flower* image.

The prints in Warhol's portfolio, *Electric Chair* 1971 (#74–83), show the effectiveness of his technique of presenting an image highly charged with meaning in a decorative style. This unsettling, unresolvable juxtaposition infuses the image with an extraordinary intensity so that its impact is much more powerful and disturbing than the unaltered photograph alone could be. The image of the electric chair resonates with psychological, sociological and political meanings which, like the *Race Riot,* probe deeply into the core of the individual's and society's consciousness and conscience. These prints, with their glowing color combinations, painterly surface textures and blurred images, add a new dimension to the handling of the electric chair theme and, like the *Marilyns* and *Flowers,* rank in quality with Warhol's paintings of the same objects.

"Someday everybody will think just what they want to think, and then everybody will probably be thinking alike; that seems to be what is happening."[11]

Warhol's portfolio, *Mao Tse-Tung* 1972 (#90–99), marks the transition between the first and second phase of his printmaking career. *Mao* was his first major new image since the 1960s and the first where paintings and prints of the same subject appear the same year. During the 1960s, Warhol's prints were almost exclusively based on paintings, while in his later period, paintings and prints are usually conceived simultaneously and, in some cases, images originating as prints inspire paintings. In the *Maos,* Warhol repeats the format of the *Marilyn* portraits done five years earlier, presenting ten variations on a single iconic image, taken from the frontispiece of *Quotations from Chairman Mao Tse-Tung.*[12]

Warhol introduces more obviously done details in this portrait as compared with the *Marilyns:* their surfaces are more painterly, and he adds hand-drawn linear markings in addition to color variations to differentiate the image. This represents the first of a number of devices he introduces into his works during the 1970s to give them more "style," as he himself put it.[13] *Mao* is Warhol's first non-American subject, but significantly the image was chosen during the year of Richard Nixon's trip to China when Mao became a subject of fascination to the American public and, as a result, a subject of interest to Warhol. The *Maos,* like Warhol's *Hammer and Sickle* series from the mid-1970s (#161–164), reveal that concepts held to be seriously threatening to the capitalist foundation of the American way of life can be absorbed into the culture as art or fashion, their revolutionary status rendered impotent.[14]

The *Maos* can also be seen as a take-off on the seemingly endless number of posters and billboards of Mao in China. Warhol did numerous portraits of *Mao* in all sizes and media, including paintings, prints, drawings and wallpaper; a 1973 exhibition in Paris consisted of almost 2,000 *Mao* images in all.[15] Through his striking combinations of intense, pure colors, Warhol transforms Mao's serious, austere image into a series of comic and attractive caricatures. Warhol's ability to affect our response to a familiar visage is likewise seen in his wittily repelling portrait of Richard Nixon in *Vote McGovern* (#84) done the same year as the *Maos.*

Warhol's prints and paintings alike, from the first phase of his career, prove his keen eye for selecting images

saturated with the most revealing cultural associations and his ability to use the medium of screenprinting to enhance the visual and conceptual impact of those images. Warhol's 1960s art provides a mirror of both the positive and negative aspects of the American Dream, whether he uses subjects as banal as soup cans and Coke bottles or as disturbing as race riots and electric chairs. A critique of society, reflecting a consistent political viewpoint, is implicit in his choice of subjects and their manner of presentation, while Warhol's stance of detached fascination adds a quality of ambivalence essential to their particular success as works of art.

Prints 1973 – 1985

"I really would still rather do just a silkscreen of the face without all the rest, but people expect just a little bit more. That's why I put in all the drawing." [16]

Since the mid-1970s, Warhol has expanded his repertory of subjects and stylistic devices, while remaining committed to silkscreen as the exclusive medium for his paintings and prints. Only two prints, both from 1974, use images taken directly from the first phase of his career: one, a retrospective survey of his major sixties images superimposed in black on black, *Untitled 12* (#120); the other, a portrait of *Merce Cunningham* (#124), printed on flowered Japanese gift wrapping paper, using one of several photographs from his 1963 *Merce* paintings. Warhol's recent prints are primarily portraits and still lifes, reflecting some continuities in theme and style as well as significant differences which distinguish his earlier and later work. His portraits from this period extend the range of mass media celebrities taken from the worlds of entertainment, sports, politics and the arts and include historical figures as well. In the *Mick Jagger* 1975 prints (#138–147), Warhol uses his own photographs and breaks away from his earlier format of repeated images by using ten different snapshots showing Jagger striking a variety of stylish poses for the camera. By using his own photographs for portraits and other subjects, which he does whenever possible beginning in 1975, Warhol eliminates a key feature of his earlier work where the fact that the image was borrowed from the mass media contributes a significant layer of meaning. From this time on, Warhol uses the direct access to media stars he has earned through his own fame to play the role of voyeur and fan through the lens of his Polaroid camera. In the *Jagger* prints and the closely

related *Ladies and Gentlemen* 1975 (#126–137), Warhol fragments the surface with patches and strips of various shapes and colors, creating collage-like, quasi-cubist effects and busier, more complicated surfaces than in his earlier prints. In addition, Warhol introduces a Matisse-like drawing style, recalling his own 1950s graphic technique, to echo and reinforce the photographic images. From this point on, both collage effects and drawing are found in most of his prints, giving them a self-consciously artistic, often arty, look and distinguishing them from his earlier silkscreens for which the impersonal, mechanical quality of painting was an essential part of their meaning.

In *Ten Portraits of Jews of the Twentieth Century* 1980 (#226–235), Warhol uses the same stylistic devices as in the *Jagger* portraits. However, the fragmented, multicolored surfaces coincide with the flamboyant poses and personalities of Mick Jagger and the transvestites in *Ladies and Gentlemen*, while in the *Portraits of Jews*, they serve primarily as ornamental background designs neither complementing nor reinforcing the subjects' personalities. In some of these portraits, particularly *Franz Kafka* (#226) and *The Marx Brothers* (#232), these pictorial devices appear to enhance the impact of the photographic image; although it is debatable whether Warhol's additions result in anything other than appealing graphic images, ultimately dependent on the effectiveness of the original photographs for their success as portraits. In his best work, the transformation occurring through his presentation of the photograph is just as crucial to the success of the work as his selection of the image. It is understandable that Warhol, who ranks as one of the major contemporary portraitists, would be intrigued by a proposal to do historical portraits. [17] But Warhol's forte as a portraitist is to show surface and surface only. While this approach is entirely suitable for his portraits of glamorous celebrities and socialites, its appropriateness for historical figures of the type in this portfolio is questionable. In addition, Warhol's unique ability to make insightful selections is not as apparent here as it is in other works.

With *Myths* 1981 (#258–267), another major portfolio of ten prints related by theme, Warhol is working with the kind of images he has been using since the beginning of his career. *Myths* specifically revives the type of subjects he used during the 1960s, when appropriating mass media images as art raised crucial questions about the role of the media in shaping cultural values. These are his first and only depictions of imaginary persons, and they represent a shift from his earlier portrait subjects, chosen because they

were living legends, mythologized in their own time. Most of the *Myths* are taken from old Hollywood films or 1950s television: the majority of them are fantasy characters from childhood; and, typical of Warhol, they are all American or Americanized subjects. Because they recall his own earlier work, childhood memories and dated media personalities, Warhol's *Myths* rely heavily on nostalgia for their impact. *Myths* are visually among Warhol's strongest prints. He eliminates the cluttered collage effects of his 1970s portraits and uses monochrome backgrounds decorated with glittering diamond dust. The resulting simplification of images and expert use of Warhol's graphic design style makes their impact immediate and effective.

Warhol's most successful recent portraits are the ones which, like *Myths*, emulate the simplicity and directness of his sixties use of the silkscreen technique, while continuing to add innovative variations. In his series of commissioned portraits of the German artist, *Joseph Beuys* 1980 and 1980/83, (#242–247), Warhol manipulates the image to augment the charisma of the individual portrayed. His selection of this particular photograph of Beuys and his use of repetition, simple color relationships and textural variations with diamond dust and flocking reveal Warhol's best qualities as a portraitist.

"Buying is more American than thinking and I'm as American as they come." [18]

Warhol's still life subjects from the second phase of his career are usually more overtly symbolic and traditional than his characteristic works of the 1960s. The *Hammer and Sickle* 1977 (#161–164) and *Skulls* 1976 (#157–160), two of his best known and strongest seventies images, are drawn directly from the realm of symbolic objects, while his earlier works transform familiar objects into symbols of contemporary life. For example, the soup can and electric chair correspond to the hammer and sickle and skull as symbols, one of ideology, the other of death. The latter, however, are used primarily as symbols, while the former are more rooted in their function as real objects and, as a result, resonate with more complex levels of meaning. Warhol's "$" images 1982 (#274–286) revive a subject used twenty years earlier in his paintings of *Dollar Bills* and are another instance of his recent preference for symbol over object. They are his most obvious representations since the *Dollar Bill* paintings of the theme of consumerism that runs through his work of the past two decades. They particularly focus on how the art system is linked to the commercial marketplace. Using repeated images of money or its symbol reinforces the fact that art itself is a consumer item and money-making venture for artist, dealer and collector alike. These images also remind the viewer of how artworks are often judged by their dollar value and illustrate the idea that, for many, art literally represents money on the walls.[19] Because, at this stage of his career, Warhol's work commands high prices, his money images have an even stronger ironic component than they did in the early 1960s when his art was not yet considered a good investment. Only an artist who has built his philosophy on the idea of Art as Business and Business as Art[20] could exhibit images of dollar signs on the walls of a Soho gallery in the 1980s and have them work both as a critique of the commercial aspect of the art system and a celebration of the power of the dollar in capitalist America.

Warhol's other still life subjects from this period, such as *Flowers* 1974 (#100–119), *Gems* 1978 (#186–189), *After the Party* 1979 (#183), *Grapes* 1979 (#190–195), *Space Fruit: Still Lifes* 1979 (#198–203), and *Shoes* 1980 (#248–257), are directly related to the iconography of traditional still lifes of flowers, fruits, dinnerware and luxury items. While they have Warhol's unique flare of wit, purposely flawed elegance and skillful decorative sensibility, they lack the conceptual dimension of his 1960s still life subjects. A case in point is the difference between his portfolios *Flowers* (1970) and *Flowers* (1974). The earlier prints, where a found photograph is abstracted into pattern, powerfully challenge the boundary between art and decoration. But the later ones, elegant and charming drawings of flowers in vases, end up looking like conventional pictures, suggesting little, if anything, of their origin as designs from a wallpaper catalogue.

Shadows 1979 (#204–225), a series of five portfolios, relies like *Flowers* (1970) and *Sunset* (1972) on abstraction for its reading as pure pattern and elaborates Warhol's recent tendency toward decoration for decoration's sake. Warhol himself described his 1979 installation of 83 *Shadow* paintings, done in silkscreen and diamond dust, as "disco decor."[21] The *Shadows* are the most abstract images Warhol has ever done, and the prints are even more abstract than the paintings. The photographs of shadows in the paintings definitely look like shadows of something, although it is impossible to figure out what, and this is an important part of their effect. The shadows in the prints barely read as shadows at all and, therefore, lack the mystique of the paintings. The prints, significantly more interesting seen in groups than individually, form flat,

non-objective patterns using diamond dust and brushwork to create textural variations.

While pure decoration plays a central role in Warhol's work, he has continued to use images with value focusing on contemporary issues. Because of Warhol's role as detached recorder of the pulse of American society, postured on the edge between decadence and innocence, sophistication and naiveté, his imagery has a range which would seem inconsistent for another artist. The blatantly homoerotic *Sex Parts* 1978 (#172–178) emerge from the flip side of the sensibility which creates *Double Mickey Mouse* 1981 (#269). Hammers and sickles coexist with gems and dollar signs; skulls with shoes; Muhammad Ali and Ingrid Bergman with Goethe and Alexander the Great. The tawdry "drag queens" from *Ladies and Gentlemen* 1975 (#126–137) and his portraits of the four living female monarchs in *Reigning Queens* 1985 (#334–349) reveal his fascination with the opposite extremes of the social hierarchy.

In his 1984 portfolios, *Details of Renaissance Paintings* (#316–327), Warhol shows his willingness to raid the most sacred bastions of art history for images which suggest a gesture of homage to the past, and at the same time, through their Pop color and poster-like style, promote a position of iconoclastic irreverence. These prints recall Warhol's 1963 *Mona Lisa* painting which used the "superstar" of Old Master icons to call attention to the role of reproductions in our experience of the art masterpiece and its transformation into cliché. *Details* develops the same idea, specifically focusing on how reproducing details frames our way of seeing art objects. Only *Botticelli, Birth of Venus, 1482* (#316–319) has the same instant recognizability to most people as the Mona Lisa. The other *Details*, although from "famous" Renaissance paintings — one by Leonardo da Vinci, one by Uccello — are more obscure parts known to a more restricted public, and the basis for their selection less obvious.

In *Ads* 1985 (#350–359), as in *Myths* 1981 (#258–267), Warhol uses the kind of mass media images which are his forte, particularly deliberately nostalgic ones. Most of the *Ads* reveal Warhol's underlying assumption of the relationship of Hollywood and consumerism. They show Hollywood selling itself (a Japanese poster advertising a James Dean film and the Paramount logo), patriotism (Donald Duck promoting war bonds) and products (Judy Garland in a Blackglama fur and the most topical ad, Ronald Reagan selling Van Heusen shirts — "won't wrinkle ever").

In his *Endangered Species* 1983 (#293–302) portfolio, Warhol takes up an unexpected subject for an artist whose imagery has been concentrated almost exclusively on cultural artifacts. When Warhol used nature subjects in the past (as in his *Flowers* and *Sunset*), the images were purposefully pushed over the edge from the real to the artificial and transformed into pure design. With *Endangered Species*, the content value is crucial to their success. Warhol uses his sense for complex and dazzling color combinations to make these images irresistibly appealing in order to underscore the environmentalist message that is the *raison d'être* for the series. While the images lack the tension that comes from the quality of ambivalence characteristic of other Warhol images, they have a directness that is captivating and entirely appropriate for the thematic issue with which he is dealing.

Endangered Species shows the attention to the craft aspect of printmaking characteristic of Warhol's recent prints, as compared to the more casual approach to technique in his earlier work. They involve complicated technical procedures, with up to nine screens and fourteen colors in a single print and an elaborate proofing process.

While Warhol's casual attitude to craft was suitable for the 1960s, the more calculated design of his recent work reflects the polished cultural style of the 1980s. Thus, *Endangered Species* is one example of how Warhol remains perfectly synchronized in both theme and style with the contemporary cultural context, as he always is in his most effective work.

Roberta Bernstein is an assistant professor at the State University of New York at Albany. Previously she taught at Barnard College and Columbia University where she received her Ph.D. in art history. She has published catalogue essays and articles on contemporary painting, sculpture and prints and has just completed a book on Jasper Johns. During the late 1960s, she worked in Andy Warhol's Factory assisting him with various art projects.

Some of the ideas developed in this essay first appeared in my review of *Andy Warhol: Das Graphische Werk 1962–1980*, published in *The Print Collector's Newsletter*, XIII, 5 (November-December 1982), 175–177.

1. Andy Warhol, Kasper König, Pontus Hultén, Olle Granath (eds.), *Andy Warhol*, catalogue of exhibition at the Moderna Museet, Stockholm, February-March 1968, unpaginated.

2. R. Crumb, quoted in "R. Crumb Keeps on Drawing," *Newsweek* (July 25, 1983), 9.

3. *Andy Warhol,* catalogue, 1968.

4. Rainer Crone, *Andy Warhol*, New York, 1970, 30.

5. John Coplans, *Andy Warhol*, Greenwich, Connecticut, 1970, 13.

6. *Andy Warhol,* catalogue, 1968.

7. Robert Rosenblum, "Andy Warhol: Court Painter to the 70s," in *Andy Warhol: Portraits of the 70s*, ed. David Whitney, New York, 1979, 14.

8. Andy Warhol, *The Philosophy of Andy Warhol (From A to B and Back Again)*, New York, 1975, 100 – 101.

9. *Andy Warhol*, catalogue, 1968.

10. David Bourdon, in "Andy Warhol: Flower," *Arts Magazine*, L, 3 (November 1975), 86, wrote: "That image was derived from a photograph that appeared in the June 1964 issue of *Modern Photography*. Warhol cropped the photograph, which showed seven flowers and 'revised' it by shifting one of the flowers. Incidentally, the flowers are hibiscus, and not, as often stated, anemones, nasturtiums or pansies."

11. Gene Swenson, "What Is Pop Art? Answers from 8 Painters, part 1," *Art News*, LXII, 7 (November 1963), 24–27.

12. Charles F. Stuckey, "Andy Warhol's Painted Faces," *Art in America*, LXVIII, 5 (May 1980), 105.

13. Quoted in C. Stuckey, 110.

14. Peter Schjeldahl, in "Warhol and Class Content," *Art in America*, LXVIII, 5 (May 1980), 118, wrote: "With the 'Maos' and 'hammers and sickles', Warhol presents an image of historic menace to the ruling class, yet the shock value is calculated. He offers his patrons both a delicious horror and a promise of emotional mastery over it: they can hang it on their walls."

15. Quoted in C. Stuckey, 105.

16. Barry Blinderman, "Modern Myths: An Interview with Andy Warhol," *Arts* Magazine, LVI, 2 (October 1981), 145.

17. B. Blinderman, in *Arts* Magazine, LV, 6 (February 1981), 15, wrote that the portfolio *Portraits of Jews* "developed from a conversation with dealer Ronald Feldman concerning a new context for the Golda Meir portraits done in 1975." Most of Warhol's recent images are inspired by commissions: the idea for the print or portfolio is suggested by the publisher or sponsoring organization, while the selection of specific images is always Warhol's.

18. A. Warhol, *Philosophy*, 229.

19. A. Warhol, in *Philosophy,* 133–134, wrote: "I like money on the wall. Say you were going to buy a $ 200,000 painting. I think you should take that money, tie it up, and hang it on the wall. Then when someone visited you the first thing they would see is money on the wall."

20. A. Warhol, *Philosophy*, 92.

21. Quoted in C. Stuckey, 105.

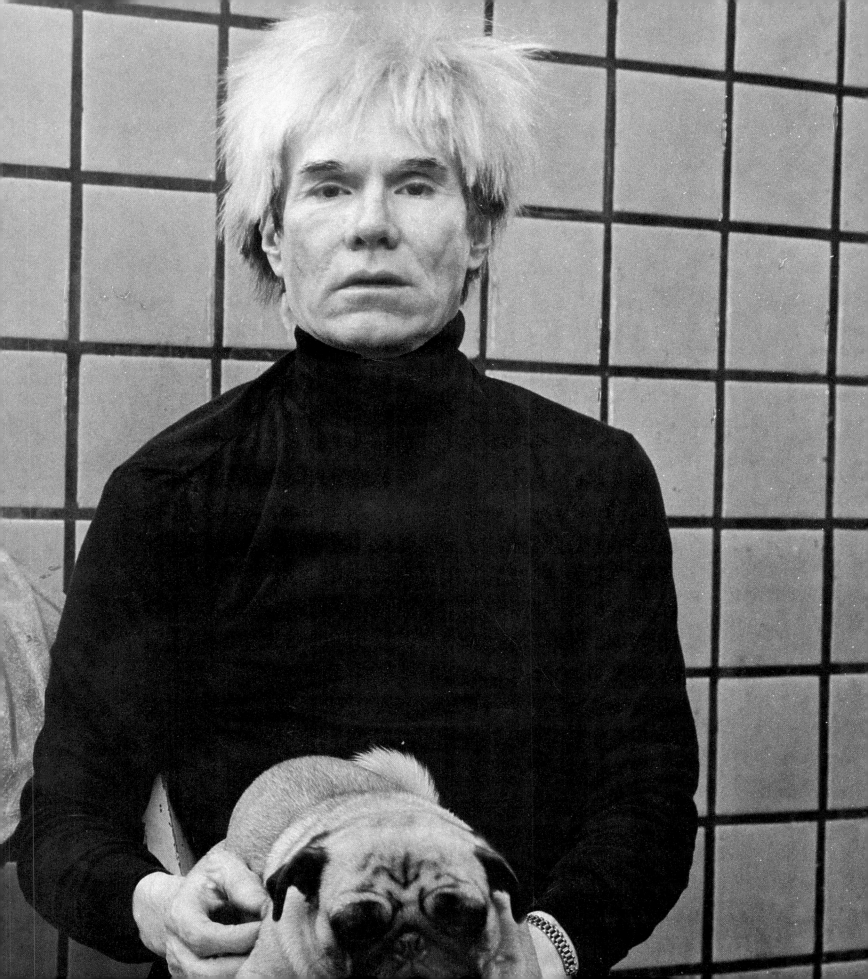

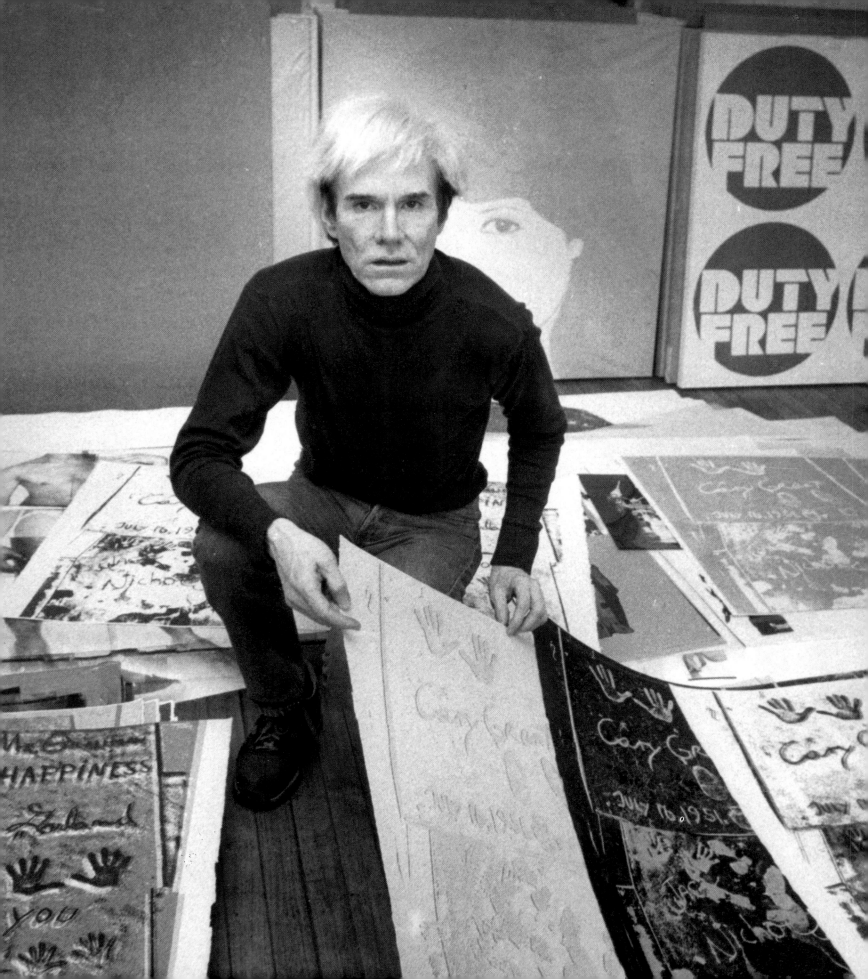

Editors' Note

This catalogue raisonné contains works in the print medium by Andy Warhol executed from 1962 to early 1985. Screenprint projects in progress at our publication date will be included in an updated edition of this catalogue.

Information was collected from publishers when available and supplemented by consultation with the artist and printers. The completeness of the documentation has varied over the years and is scarcer before 1977 when record keeping became more thorough.

Trial proofs, prints pulled during the proofing process which document color changes, began to be recorded and made into small editions in 1980 with the publication of *Ten Portraits of Jews of the Twentieth Century* (#226–235). Since no data was kept on such proofs before that date, there are some prints in circulation which have not been documented. Editions personally published by the artist, such as *Sunset* (#85–88) and *Dollar Signs* (#274–286), are assembled and numbered as regular editions, not as trial proof editions, even though each print is unique. The *Double Mickey Mouse,* 1981 (#269) and the *Anniversary Donald Duck,* 1985 (#360) in editions of 25 and 30 respectively are also treated as regular editions, not trial proof editions. We have only photographed some examples of these prints. In addition, there are a limited number of prints dedicated to friends that are signed and unnumbered.

We have enumerated works published in limited editions which, in most instances, are both signed and numbered. The exceptions are *Campbell's Soup Can on Shopping Bag* (#4), *Marilyn Monroe I Love Your Kiss Forever Forever* (#5), *Flower* (#6), *Liz* (#7), *S & H Green Stamps* (#9), *Banana* (#10), *Lincoln Center Ticket* (#19), *SAS Passenger Ticket* (#20), *Marcia and Frederick Weisman* (#122, #123) and *Sachiko* (#154–155) which are signed but unnumbered. Although *Kiss (Bela Lugosi),* 1963, *Cagney,* 1964 and *Suicide,* 1964 are screenprints on paper in unrecorded editions of approximately 5 copies, they are not listed because Warhol considers them to be unique drawings. (See page 112.)

Although we have not listed posters, the *Lincoln Center Ticket* (#19) and *SAS Passenger Ticket* (#20) are included because they were also made into limited editions on special paper. We have not selected three-dimensional objects, banners or books even though they are often done in limited editions but have concentrated on two-dimensional works on paper or plastic. *Kiss,* 1966 (#8), from the

N9₀³⁴

portfolio *Seven Objects in a Box,* is included as an example of a screenprint on plexiglas published in a large edition of 75. In 1965 and 1966, Warhol also did *Large Sleep, Kiss, Empire State Building, Couch, Eat* and *Sleep,* screenprints on plexiglas based on frames from his films. These were produced in unrecorded editions of approximately 5 or 6 copies, and it is rare to find them in circulation. (See page 112.)

This catalogue raisonné is as complete as possible at this date. We would like to acknowledge the pioneering efforts of Rainer Crone, *Andy Warhol,* 1970 and Hermann Wünsche, *Andy Warhol Das Graphische Werk 1962–1980.* In such cases where our data differs from the text of either of their books, our research indicates that our changes are correct.

The publication of this catalogue would not have been possible without the cooperation of many colleagues. We gratefully acknowledge the assistance of Andy Warhol who not only loaned us the majority of the prints to be photographed for the catalogue but reviewed the documentation and provided valuable information about early works. Rupert Jasen Smith, Warhol's printer since 1977, made data available about all prints produced since that year. We are deeply indebted to him for his insights, ideas, encouragement and dedication to the project which he always approached with patience and enthusiasm. D. James Dee and Toni Dee were a joy to work with during the long photographic process, and we thank Sean Elwood and Martina Batan for their assistance at those sessions and Barbara Goldner for coordinating the black and white photographs in the catalogue. Others who shared their knowledge and deserve special mention and gratitude are Fred Hughes, Vincent Fremont, Nancy Grubb, David Whitney, Robert Monk, Jay Shriver, Michael Egan, Rosa Esman, Billy Klüver, Julie Martin, Nora Halpern and Lennie Levine.

Frayda Feldman Jörg Schellmann

Catalogue Raisonné

Illustrations and Text

1 Cooking Pot 1962

Etching, 10" x 7½" (25.4 x 19 cm), image 6" x 4¼"
(15.2 x 10.8 cm), printed on Rives.
Edition: 60, signed with a chopmark, numbered and dated
1962 in pencil on verso.
Published in the portfolio *American Avant Garde* containing
works by twenty artists.
Printer: M. Leblanc, Paris
Publisher: Arturo Schwarz, Milan

2a – 2d $1.57 Giant Size 1963

Screenprint, 12¼" x 12¼" (31.2 x 31.2 cm), printed on coated record
cover stock. The cover is printed in four different day-glo colors
(#2a yellow, #2b hot pink, #2c white, #2d green) with black lettering.
Edition: 75, 10 HC, signed and numbered in pen on verso.
Unlimited copies unsigned and unnumbered.
Printers: Andy Warhol and Billy Klüver, New York
Publisher: Billy Klüver, New York

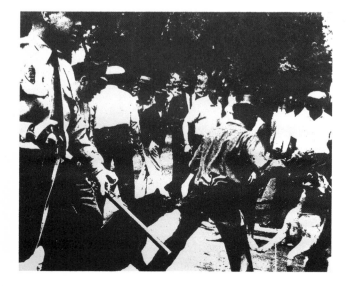

3 Birmingham Race Riot 1964

Screenprint, 20" x 24" (50.8 x 61 cm), printed on white paper.
Edition: 500, 10 AP, unsigned at publication date.
Published in the portfolio *Ten Works by Ten Painters* which is numbered
but unsigned.
Printer: Ives-Sillman, Inc., New Haven
Publisher: Wadsworth Atheneum, Hartford

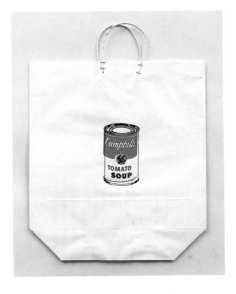

4 Campbell's Soup Can on Shopping Bag 1964

Screenprint, 6" x 3¼" (15.2 x 8.3 cm),
printed on a shopping bag, 19¼" x 17" (48.8 x 43.2 cm).
Edition: approximately 300, signed in ball point pen on verso;
some initialled AW below the soup can on right.
Published for the *Supermarket Show*
at the Paul Bianchini Gallery.
Publisher: Paul Bianchini Gallery, New York

5 Marilyn Monroe I Love Your Kiss Forever Forever 1964

Lithograph printed on two separate pieces of paper as a double-page
spread with a print by another artist on verso.
Edition: 100 printed on Arches, 16" x 22¾" (40.6 x 57.8 cm),
signed in pencil vertically in lower right margin.
2,000 printed on white paper, unsigned.
Published in an unbound book compiled by Walasse Ting entitled
1¢ Life containing works by twenty-eight artists. This book is
numbered in an edition of 2,000.
The limited book on Arches is numbered in an edition of 100.
Printer: Maurice Beaudet, Paris
Publisher: E. W. Kornfeld, Bern

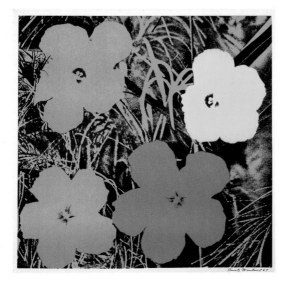

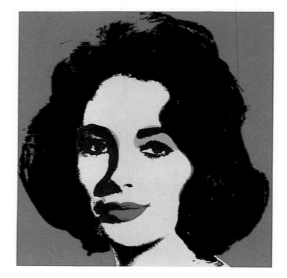

6 Flower 1964

Offset lithograph, 23" x 23" (58.4 x 58.4 cm),
printed on white paper.
Edition: approximately 300, signed and dated '64
in pen lower right.
Published to announce the exhibition of *Flower*
paintings.
Printer: Total Color, New York
Publisher: Leo Castelli Gallery, New York

7 Liz 1964

Offset lithograph, 23⅛" x 23⅛" (58.7 x 58.7 cm),
printed on white paper.
Edition: approximately 300, signed and dated '64 in ball point
pen.
There are five or six with white backgrounds, signed
in pencil on verso.
Printer: Total Color, New York
Publisher: Leo Castelli Gallery, New York

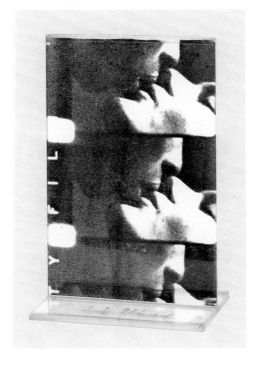

8 Kiss 1966

Screenprint on plexiglas, 12½" x 8" x 5¼"
(31.7 x 20.3 x 13.3 cm).
Edition: 75, 25 AP lettered A-Y, signature embossed and
number incised on plexiglas mount.
Published in a portfolio *Seven Objects in a Box* containing
works by seven artists.
Fabricator: Knickerbocker Machine & Foundry, Inc., New York
Publisher: Tanglewood Press, Inc., New York

9 S & H Green Stamps 1965

Offset lithograph, 23" x 23¾" (58.4 x 60.2 cm), printed on white paper.
Edition: approximately 300, some signed in ball point pen; some are
dated. Six thousand folded prints were used as announcements for
the Warhol exhibition at the Institute of Contemporary Art
in Philadelphia.
Printer: Eugene Feldman, Philadelphia
Publisher: Institute of Contemporary Art, Philadelphia

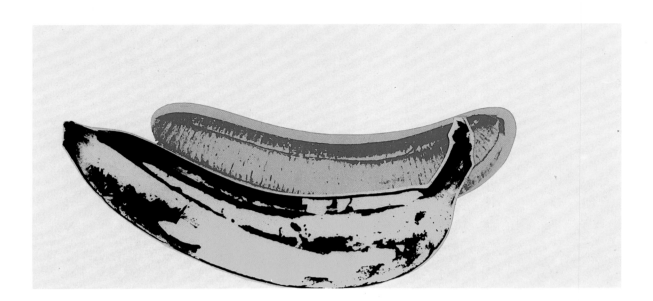

10　Banana　1966

Screenprint on laminated plastic which can be peeled off a screenprint on white styrene.
Peel image 17⅞" x 36¼" (45.5 x 92 cm), sheet 24" x 53¼" (61 x 135.2 cm).
When peeled off, one can see the inside of the banana printed in red.
Edition: approximately 300, signed on verso; some are dated.
Publisher: Factory Additions, New York

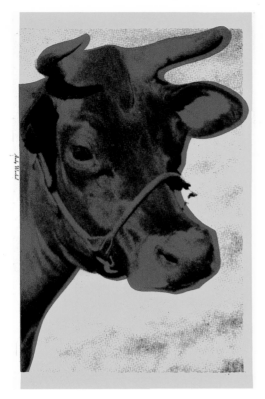

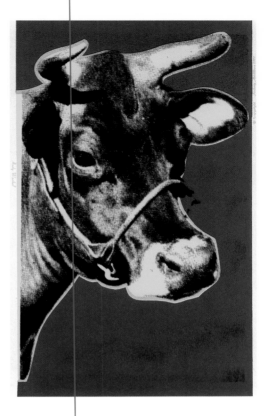

11 Cow 1966

Screenprint, 45½" x 29¾" (115.5 x 75.5 cm),
printed on wallpaper.
Edition: unlimited, but 100 were rubber stamp signed and
numbered on verso. Andy Warhol's signature is printed
vertically in left margin.
Printer: Bill Miller's Wallpaper Studio, Inc., New York
Publisher: Factory Additions, New York

12 Cow 1971

Screenprint, 45½" x 29¾" (115.5 x 75.5 cm),
printed on wallpaper.
Edition: unlimited, but 150 were signed, numbered and dated
in ball point pen on verso. Andy Warhol's signature is printed
vertically in left margin.
Printer: Bill Miller's Wallpaper Studio, Inc., New York
Publisher: Factory Additions, New York

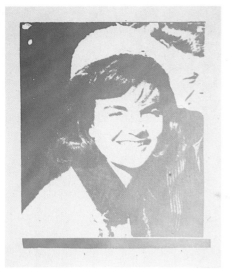

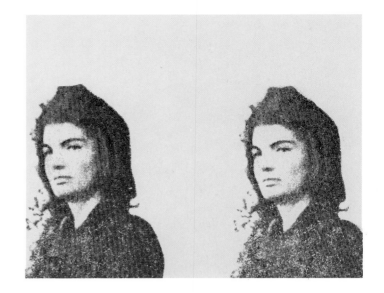

13　Jackie I　1966

Screenprint, 24" x 20" (61 x 50.8 cm), image 20⅛" x 17⅛"
(52.5 x 43.5 cm), printed on white paper.
Edition: 200, 50 AP numbered in Roman numerals, rubber
stamp signed and numbered in pencil on verso.
Published in the portfolio *Eleven Pop Artists I*.
Printer: KMF, Inc., New York
Publisher: Original Editions, New York

14　Jackie II　1966

Screenprint, 24" x 30" (61 x 76.2 cm), printed on white paper.
Edition: 200, 50 AP numbered in Roman numerals,
rubber stamp signed and numbered in pencil on verso.
Published in the portfolio *Eleven Pop Artists II*.
Printer: KMF, Inc., New York
Publisher: Original Editions, New York

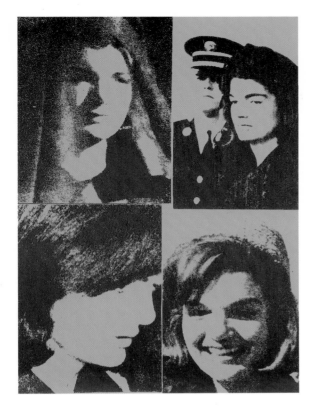

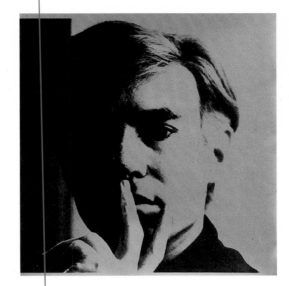

15 Jackie III 1966

Screenprint, 40" x 30" (101.6 x 76.2 cm),
printed on white paper.
Edition: 200, 50 AP numbered in Roman numerals,
rubber stamp signed and numbered in pencil on verso.
Published in the portfolio *Eleven Pop Artists III*.
Printer: KMF, Inc., New York
Publisher: Original Editions, New York

16 Self-Portrait 1967

Screenprint, 23" x 23" (58.4 x 58.4 cm),
printed on silver coated paper.
Edition: approximately 300, signed and
numbered in pen on verso.
Published to announce a Warhol exhibition
at the Leo Castelli Gallery.
Printer: Total Color, New York
Publisher: Leo Castelli Gallery, New York

17 Portraits of the Artists 1967

One hundred colored styrene boxes, each 2" x 2" (5 x 5 cm),
silkscreened with a portrait of one of the ten artists in the
Ten from Leo Castelli portfolio. Overall size of piece is
20" x 20" (50.8 x 50.8 cm) containing ten portraits of each artist.
Edition: 200, 25 for collaborators lettered A-Y. A small AW and
number are incised on bottom right box which is Warhol's portrait.
Printer: Fine Creations, Inc., New York
Publisher: Tanglewood Press, Inc., New York

18 *Paris Review* Poster 1967

Screenprint with dye cut holes, 37" x 27⅛"
(94 x 69 cm), printed on cream paper.
Edition: 150, rubber stamp signed and numbered
in pencil lower right.
Published in a series of prints by major contemporary
artists to publicize and provide financial support for
the *Paris Review* magazine.
Publisher: *Paris Review,* New York

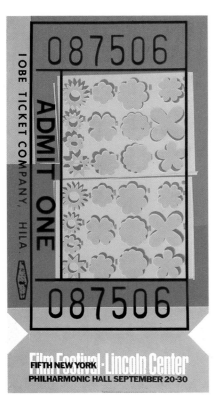

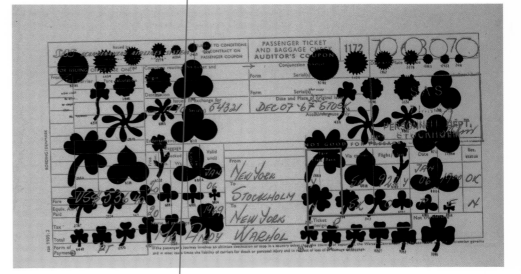

19 Lincoln Center Ticket 1967

Screenprint, 45" x 24" (114.4 x 61 cm),
printed on opaque acrylic.
Edition: approximately 200, signed with
an engraving needle on verso.
Published to commemorate the Fifth
New York Film Festival at Lincoln Center.
Publisher: Leo Castelli Gallery, New York

20 SAS Passenger Ticket 1968

Screenprint, 26¾" x 48¾" (68 x 124 cm), printed on white paper.
Edition: 250, signed on verso.
Published on the occasion of a Warhol exhibition at the Moderna Museet.
Printer: Stig Arbam AB, Malmö
Publisher: Moderna Museet, Stockholm

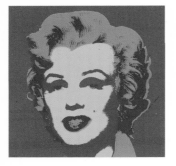

21 Marilyn 1967

Screenprint, 6" x 6" (15.2 x 15.2 cm), printed on white paper.
Edition: 100, numerous APs, signed and numbered in pencil on verso;
some are signed and unnumbered; some are dated.
Published as a flyer to announce the publication of the *Marilyn* portfolio.
Printer: Aetna Silkscreen Products, Inc./Du-Art Displays, New York
Publisher: Factory Additions, New York

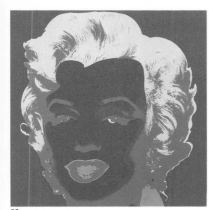

22

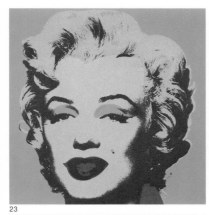

23

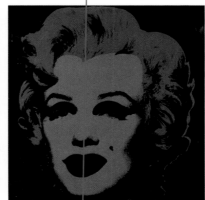

24

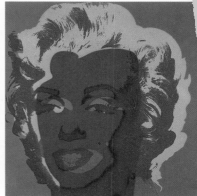

25

26

27

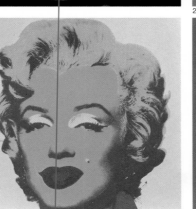

28

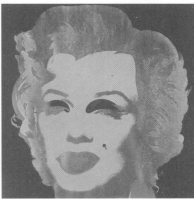

29

30

31

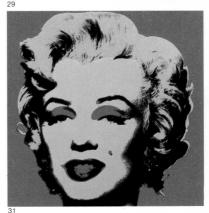

22 – 31 Marilyn 1967

Portfolio of ten screenprints, 36" x 36" (91.5 x 91.5 cm), printed on white paper.
Edition: 250, 26 AP lettered A-Z, signed in pencil and numbered with rubber stamp on verso;
some prints are only initialled on verso; some are dated.
Printer: Aetna Silkscreen Products, Inc./Du-Art Displays, New York
Publisher: Factory Additions, New York

Cover of Flash-November 22, 1963 1968

Screenprint cover of *Flash-November 22, 1963* portfolio, 22½" x 44¾" (57.2 x 113.7 cm), printed on fabric mounted on cardboard, unsigned and unnumbered.

43a b c Flash-November 22, 1963 1968

Examples of three extra screenprints in portfolios lettered A-J.

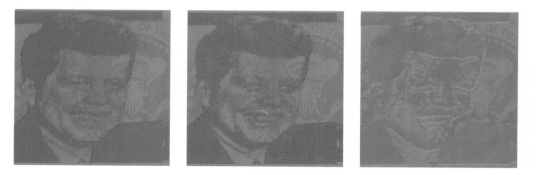

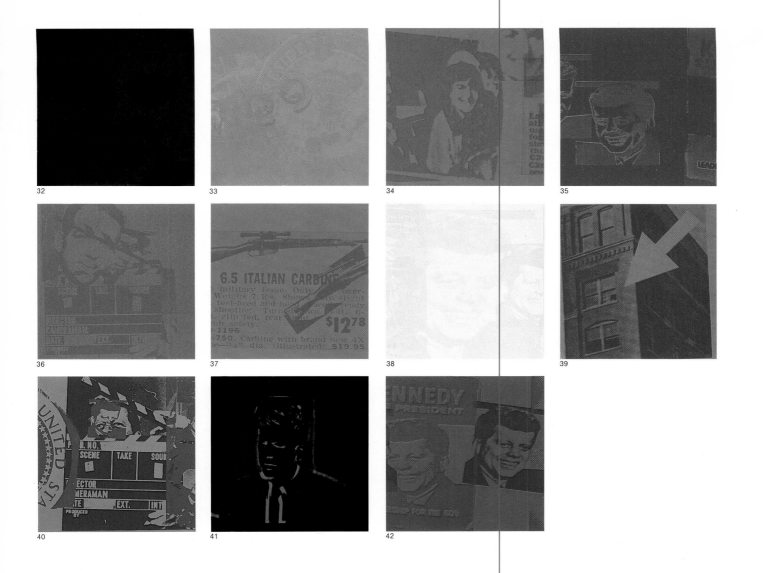

32 – 42 Flash-November 22, 1963 1968

Portfolio of eleven screenprints, colophon and text, 21" x 21" (53.3 x 53.3 cm), printed on white paper.
The prints, wrapped with the screenprint cover, are in a plexiglas box, 23" x 22½" x 2" (58.4 x 57.2 x 5 cm).
Edition: 200, 26 numbered in Roman numerals; 10 lettered A-J have three additional screenprints,
each of which is a composite of images from #33 and #38.
Each print is signed in ball point pen on verso; the colophon is signed and numbered in ball point pen.
Printer: Aetna Silkscreen Products, Inc., New York
Publisher: Racolin Press, Inc., Briarcliff Manor

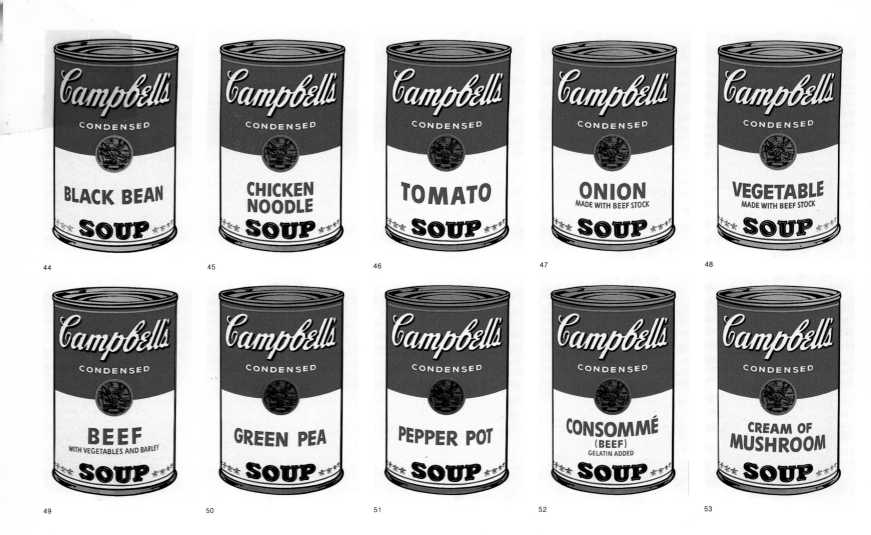

44 — 53 Campbell's Soup I 1968

Portfolio of ten screenprints, 35" x 23" (88.9 x 58.4 cm), printed on white paper.
Edition: 250, 26 AP lettered A-Z, signed in ball point pen and numbered with rubber stamp on verso.
Printer: Salvatore Silkscreen Co., Inc., New York
Publisher: Factory Additions, New York

54 55 56 57 58

59 60 61 62 63

54 – 63 Campbell's Soup II 1969

Portfolio of ten screenprints, 35" x 23" (88.9 x 58.4 cm), printed on white paper.
Edition: 250, 26 AP lettered A-Z, signed in ball point pen and numbered with rubber stamp on verso.
Printer: Salvatore Silkscreen Co., Inc., New York
Publisher: Factory Additions, New York

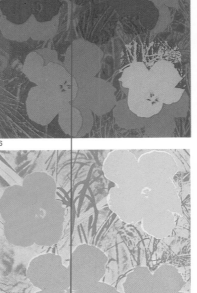

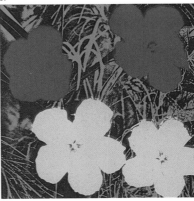

64

65

66

67

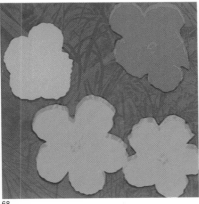

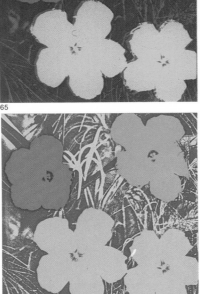

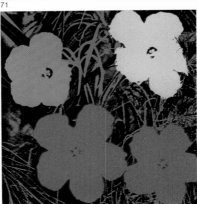

68

69

70

71

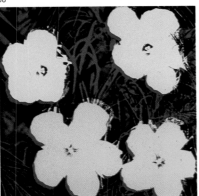

72

73

64 – 73 Flowers 1970

Portfolio of ten screenprints, 36" x 36" (91.5 x 91.5 cm), printed on white paper.
Edition: 250, 26 AP lettered A-Z, signed in ball point pen and numbered with rubber stamp on verso.
There are 40 unsigned proofs marked on verso that they are for exhibition purposes only; they are dated '70.
Printer: Aetna Silkscreen Products, Inc./Du-Art Displays, New York
Publisher: Factory Additions, New York

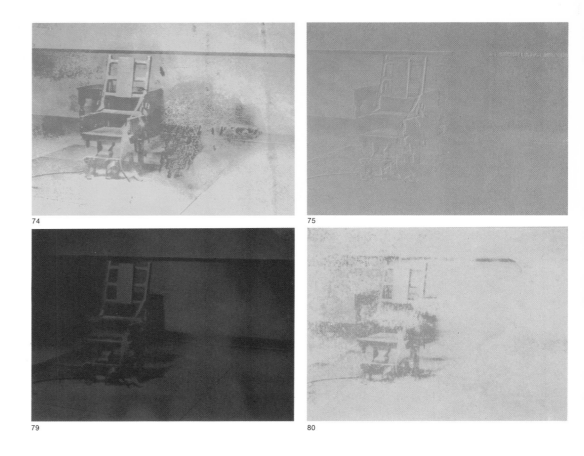

74 – 83 Electric Chair 1971

Portfolio of ten screenprints, 35½" x 48" (90.2 x 121.9 cm), printed on white paper.
Edition: 250, 50 AP numbered in Roman numerals, signed and dated '71 in ball point pen
and numbered with rubber stamp on verso.
Printer: Silkprint Kettner, Zurich
Publisher: Bruno Bischofberger, Zurich

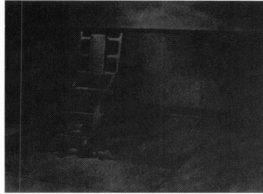

76

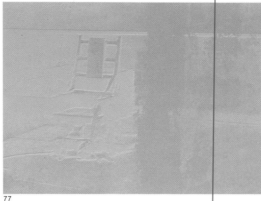

77

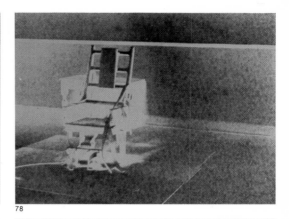

78

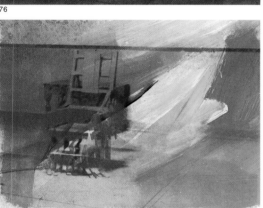

81

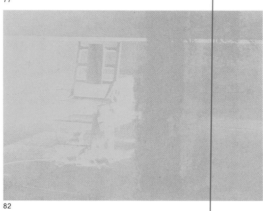

82

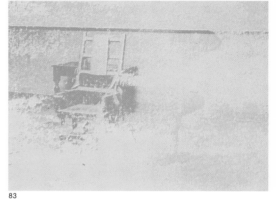

83

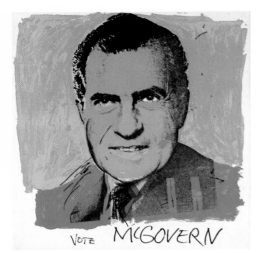

84 Vote McGovern 1972

Screenprint, 42" x 42" (106.7 x 106.7 cm), printed on Arches.
Edition: 250, 23 assorted proofs, signed and numbered in pencil on verso.
Published to raise funds for the George McGovern campaign for President.
Printer: Jeff Wasserman at Gemini G.E.L., Los Angeles
Publisher: Gemini G.E.L., Los Angeles

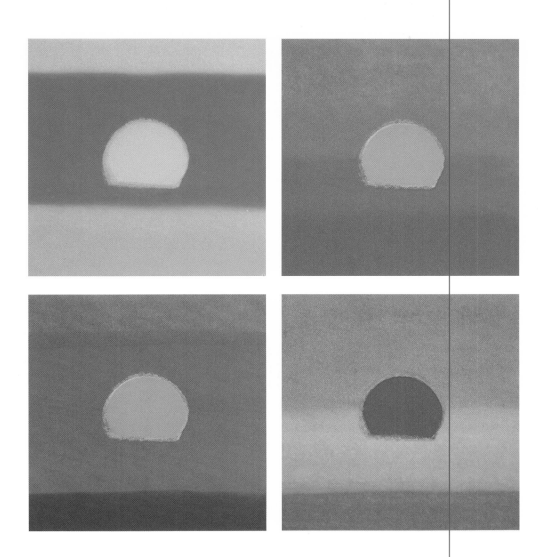

85 – 88 Sunset 1972

Screenprint, 34" x 34" (86.4 x 86.4 cm), printed on white paper.
Edition: 632 unique prints divided as follows: 40 portfolios containing 4 prints each,
signed and numbered in pencil on verso.
The remaining 472 prints were used by architects Johnson & Burgee
in the Marquette Inn, Minneapolis.
In 1981, upon removal from the hotel, these prints were stamped on verso *Hotel Marquette
Prints* and signed, numbered and dated. Two were marked HC.
Printer: Salvatore Silkscreen Co., Inc., New York
Publisher: Factory Additions, New York

89 Mao 1973

Sequential Xerox print, 11" x 8¹/₂" (27.9 x 21.6 cm), printed on 100% rag
typewriter paper.
Edition: 300, 30 AP, 31 PP, signed and numbered in ball point pen on verso.
Published in *The New York Collection for Stockholm* portfolio containing
works by thirty artists to support a project to buy a collection of works by
New York artists of the '60s for the Moderna Museet.
Printer: Xeroxed by Julie Martin
Publisher: Experiments in Art and Technology, New York

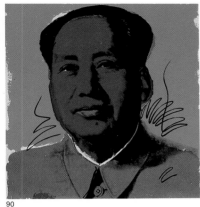 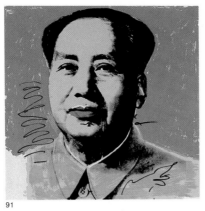 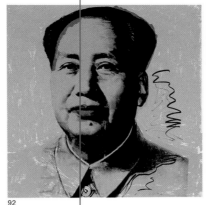 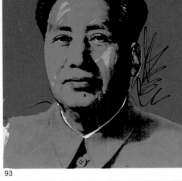

90

91

92

93

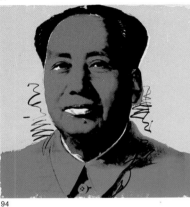 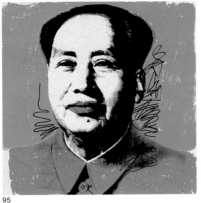 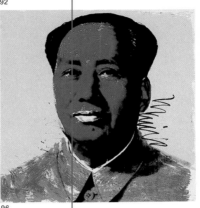 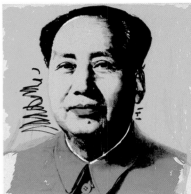

94

95

96

97

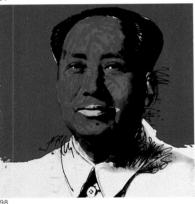 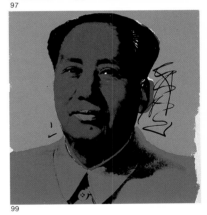

98

99

90 – 99 Mao Tse-Tung 1972

Portfolio of ten screenprints, 36" x 36" (91.5 x 91.5 cm), printed on white paper.
Edition: 250, 50 AP, signed in ball point pen and numbered with rubber stamp on verso.
Printer: Styria Studio, Inc., New York
Publisher: Peter M. Brant, New York

100

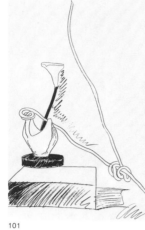
101

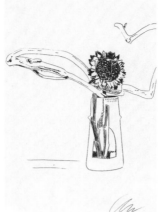
102

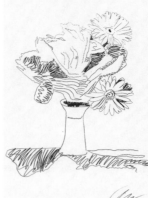
103

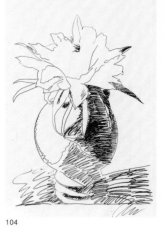
104

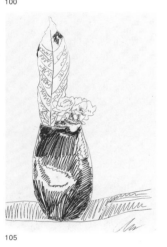
105

106

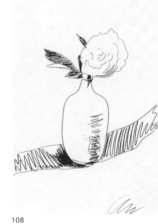
107

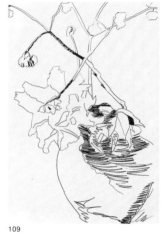
108

109

100 – 109 Flowers (Black and White) 1974

Portfolio of ten screenprints, 40⅞" x 27¼" (103.8 x 69.2 cm), printed on Arches.
Edition: 100, signed Andy Warhol N.Y. and numbered in pencil on verso, initialled AW in pencil lower right.
Printer: Alexander Heinrici, New York
Publishers: Peter M. Brant, Castelli Graphics and Multiples, Inc., New York

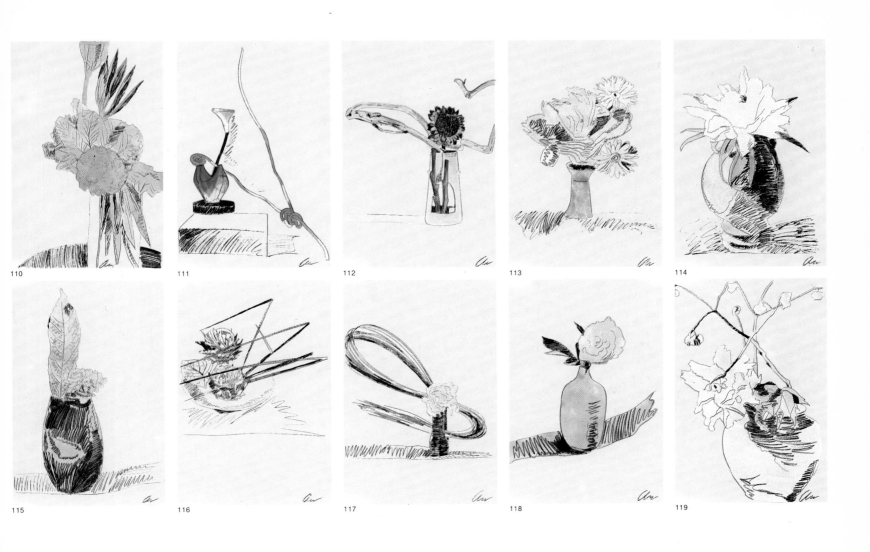

110 – 119 Flowers (Hand Colored) 1974

Portfolio of ten screenprints hand colored with Dr. Martin's analine watercolor dyes, 40⅞" x 27¼" (103.8 x 69.2 cm), printed on Arches. Each print is unique.
Edition: 250, 50 AP, signed, numbered and dated '74 in pencil on verso, initialled AW in pencil lower right.
The AP prints are not dated.
Printer: Alexander Heinrici, New York
Publishers: Peter M. Brant, Castelli Graphics and Multiples, Inc., New York

120 Untitled 12 1974

Screenprint, 30" x 22" (76.2 x 55.9 cm), image 19" x 16"
(48.2 x 40.6 cm), printed on Arches.
Edition: 100, 10 AP, 3 PP, signed, numbered and dated '74
in ball point pen on verso. The proofs are not dated.
Published in the *For Meyer Schapiro Portfolio* containing
works by twelve artists.
Printer: Alexander Heinrici, New York
Publisher: The Committee to Endow a Chair in Honor of
Meyer Schapiro at Columbia University, New York

121 Paloma Picasso 1975

Screenprint, 41" x 29¹/₂" (104.2 x 74.9 cm), printed on Arches.
Edition: 90, 15 AP, 3 PP, 30 HC, 30 numbered in Roman numerals,
signed and numbered in pencil on verso.
Published in the portfolio *Hommage à Picasso* containing works by
fifty-four artists. It was published after his death in 1973.
Printer: Alexander Heinrici, New York
Publishers: Propyläen-Verlag, Berlin; Pantheon Presse, Rome

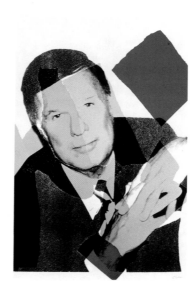

122 Marcia Weisman 1975

123 Frederick Weisman 1975

Two screenprints, 44" x 28¾" (111.8 x 73 cm),
printed on D'Arches Watercolor cut from a roll.
Edition: 10, signed AW in pencil #122 lower left, #123 lower
right.
Publisher: Andy Warhol Enterprises, Inc., New York

124　Merce Cunningham I　1974

Screenprint, 30" x 20" (76.2 x 50.8 cm),
printed on Japanese gift wrapping paper.
Edition: 100, 30 AP, 3 PP, 5 HC signed and numbered
in pencil on verso.
Published in a portfolio *Cunningham I* containing
works by seven artists to raise funds for the
Merce Cunningham Dance Company.
Printer: Alexander Heinrici, New York
Publishers: Castelli Graphics and Multiples, Inc.,
New York

125　Merce Cunningham II　1979

Screenprint, 30" x 20" (76.2 x 50.8 cm),
printed on Japanese gift wrapping paper.
Edition: 25, signed, numbered and dated 1979 in pencil on verso.
Printer: Rupert Jasen Smith, New York
Publisher: Multiples, Inc., New York

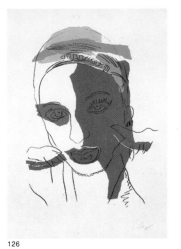 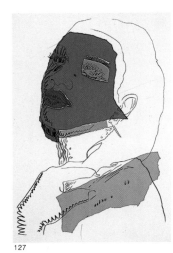

126 127

126 Ladies and Gentlemen 1975

Screenprint, 39¼" x 27½" (99.7 x 69.9 cm), printed on white paper.
Edition: 150, signed AW in pencil lower right and numbered on verso.
Publisher: Studio G7, Bologna

127 Ladies and Gentlemen 1975

Screenprint, 37¹/₂" x 25¹/₂" (95.3 x 64.7 cm),
printed on white rag paper.
Edition: 250, 50 numbered in Roman numerals, signed and numbered
in pencil on verso.
Publishers: Jabik and Colophon Editori and Mazzotta Editori, Milan

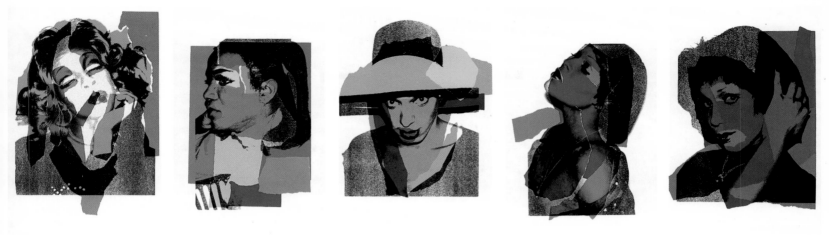

128 129 130 131 132

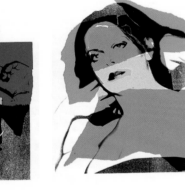 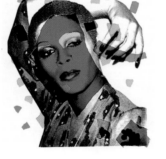 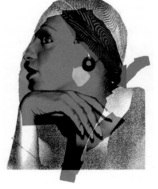 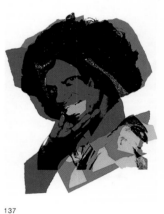

133 134 135 136 137

128 – 137 Ladies and Gentlemen 1975

Portfolio of ten screenprints, 43$^1/_2$" x 28$^1/_2$" (110.5 x 72.3 cm), printed on Arches.
Edition: 250, 25 AP, 3 PP, signed, numbered and dated '75 in pencil on verso.
Printer: Alexander Heinrici, New York
Publisher: Gabriele Mazzotta, Milan

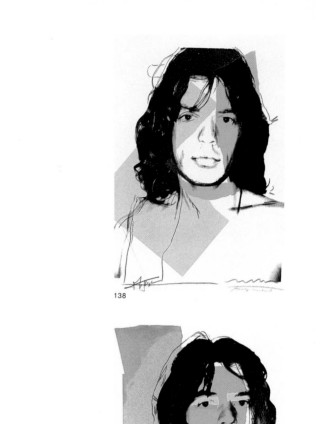

138

143

138 – 147 Mick Jagger 1975

Portfolio of ten screenprints,
43¹/₂" x 29" (110.5 x 73.7 cm),
printed on D'Arches Watercolor (Rough

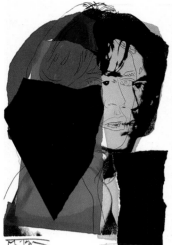
139

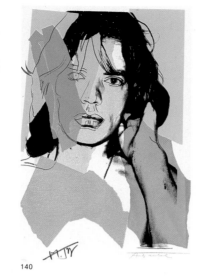
140

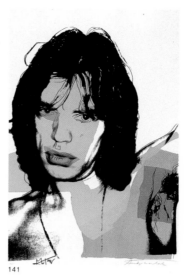
141

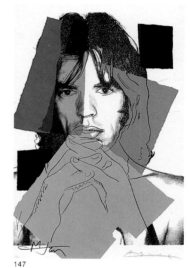
142

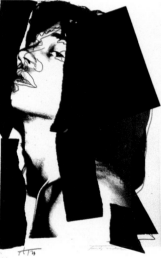
144

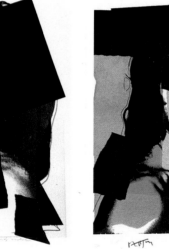
145

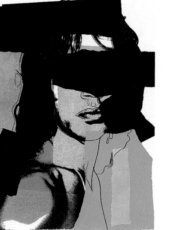
146

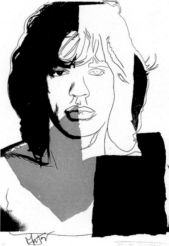
147

Edition: 250, 50 AP, 3 PP, signed in pencil lower right and numbered in pencil lower left.
Mick Jagger signed the prints in green, black or red felt pen lower left.
Printer: Alexander Heinrici, New York; Publisher: Seabird Editions, London

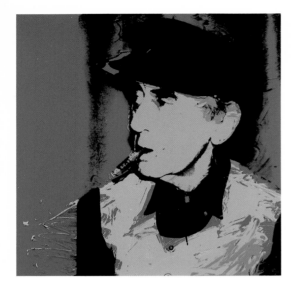

148 Man Ray 1975

Screenprint, 31¹/₂" x 31¹/₂" (80 x 80 cm),
printed on Strathmore.
Edition: 250, signed and numbered in pencil.
Printer: Il Fauno, Milan
Publisher: Luciano Anselmino, Milan

149 Man Ray 1975

Screenprint, 13¾" x 13¾" (34.9 x 34.9 cm),
printed on white paper.
Edition: 100, signed and numbered.
Printer: Il Fauno, Milan
Publisher: Luciano Anselmino, Milan

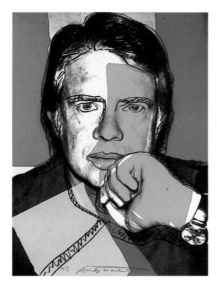

150 Jimmy Carter I 1976

Screenprint, 39¼" x 29½"
(99.7 x 74.9 cm), printed on Strathmore.
Edition: 50, 25 AP, signed and numbered
in pencil lower center.
The edition of 50 is also signed by Jimmy Carter.
Published to raise funds for the
Jimmy Carter campaign for President.
Printer: Gem Screens, New York
Publisher: Democratic National Committee

151 Jimmy Carter II 1977

Screenprint, 39¼" x 29½" (99.7 x 74.9 cm),
printed on Strathmore.
Edition: 125, 25 AP, signed and numbered
in felt pen lower left. The edition of 125 is also
signed by Jimmy Carter.
Published to raise funds for the
Jimmy Carter campaign for President.
Printer: Rupert Jasen Smith, New York
Publisher: Democratic National Committee

152 Jimmy Carter III 1977

Screenprint, 28¼" x 20½" (71.7 x 52.1 cm),
printed on J. Green.
Edition: 100, 20 AP, 2 PP, 1 HC, signed
and numbered in pencil lower center.
Published in the Inaugural Portfolio containing
works by five artists to commemorate the
inaugural celebration.
Printer: Rupert Jasen Smith, New York
Publisher: Democratic National Committee

153 Lillian Carter 1977

Screenprint, 39¼" x 29½" (99.7 x 74.9 cm),
printed on Strathmore.
Edition: 50, 20 AP, signed and numbered in pencil lower center.
Published to raise funds for the Jimmy Carter campaign for President.
Printer: Gem Screens, New York
Publisher: Democratic National Committee

154

155

156 Carter Burden 1977

Screenprint, 40" x 28¼" (101.6 x 71.7 cm),
printed on Italia.
Edition: 200, 2 PP, signed and numbered in
pencil lower left.
Published to raise funds for the Carter Burden
campaign for President of the New York City
Council.
Printer: Rupert Jasen Smith, New York
Publisher: Andy Warhol Enterprises, Inc.,
New York

154 – 155 Sachiko 1977

Two screenprints, 40" x 30¼" (101.6 x 76.9 cm), printed on Strathmore.
Edition #154: 7, 1 PP, signed in pencil lower right. There is one oversized proof
on newsprint signed in felt pen vertically in lower left margin.
Edition #155: 3, signed in pencil lower right.
Printer: Rupert Jasen Smith, New York
Publisher: Andy Warhol Enterprises, Inc., New York

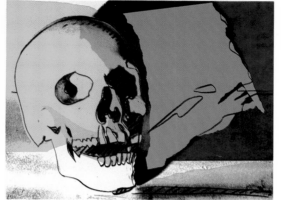

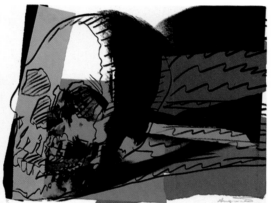

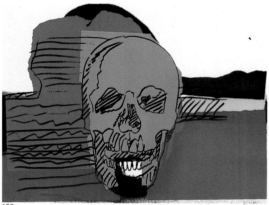

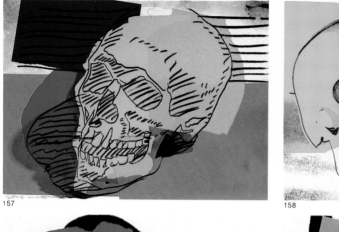

157 – 160 Skulls 1976

Portfolio of four screenprints, 30" x 40" (76.2 x 101.6 cm), printed on Strathmore.
Edition: 50, 10 AP, signed and numbered in pencil as follows: #157 and #159 lower left,
#158 lower center; #160 signed lower right, numbered lower left.
Printer: Gem Screens, New York
Publisher: Andy Warhol Enterprises, Inc., New York

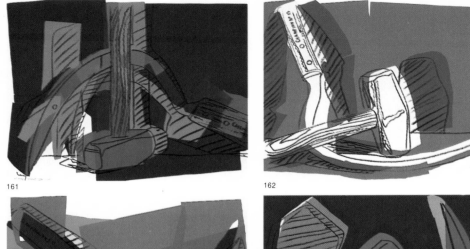

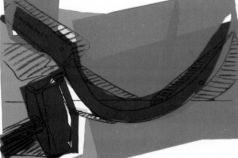
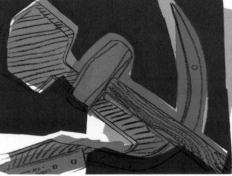

161 – 164 Hammer and Sickle 1977

Portfolio of four screenprints, 30" x 40" (76.2 x 101.6 cm), printed on Strathmore.
Edition: 50, 10 AP, 2 PP, 1 HC, signed and numbered in pencil lower left.
Printer: Rupert Jasen Smith, New York
Publisher: Andy Warhol Enterprises, Inc., New York

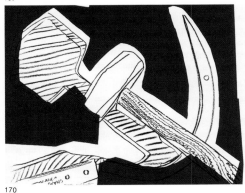

165

166

167

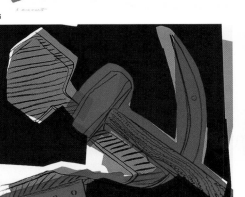

168

169

170

171

165 – 171 Hammer and Sickle (Special Edition) 1977

Portfolio of seven screenprints, 30" x 40" (76.2 x 101.6 cm), printed on Strathmore.
#164 is shown in the five separate colors of the print progression plus one with only the drawing line and
one with the black printer like the edition in registration with the drawing line.
Edition: 10, signed and numbered in pencil lower center except #165 and #166 lower left.
Printer: Rupert Jasen Smith, New York
Publisher: Andy Warhol Enterprises, Inc., New York

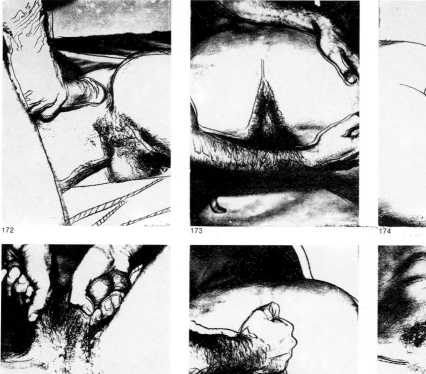

172 — 177 Sex Parts 1978

Portfolio of six screenprints, 31" x 23¼" (78.7 x 59 cm), printed on HMP.
Edition: 30, 5 AP, 1 PP, signed and numbered in pencil lower right.
There is a signed copy of #172 which is marked HC.
Printer: Rupert Jasen Smith, New York
Publisher: Andy Warhol Enterprises, Inc., New York

178 Fellatio 1978

Screenprint, 31" x 23¼" (78.7 x 59 cm), printed on HMP.
Edition: 30, 4 AP, 1 PP, signed and numbered in pencil lower right.
There is one signed but unnumbered print.
Printer: Rupert Jasen Smith, New York
Publisher: Andy Warhol Enterprises, Inc., New York

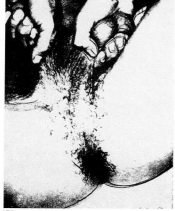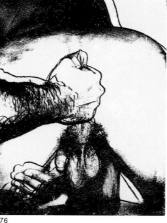

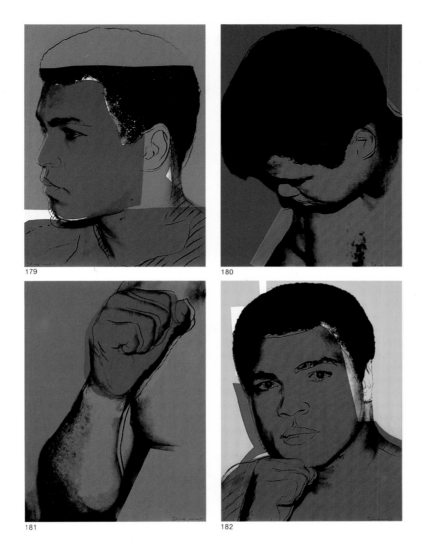

179

180

181

182

179 – 182 Muhammad Ali 1978

Portfolio of four screenprints, 40" x 30" (101.6 x 76.2 cm),
printed on Strathmore.
Edition: 150, 25 AP, 1 PP, signed and numbered in felt pen
lower right except #179 lower left.
Printer: Rupert Jasen Smith, New York
Publisher: Andy Warhol Enterprises, Inc., New York

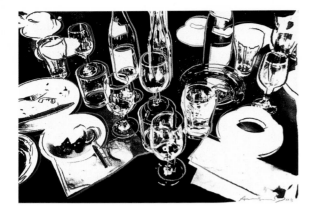

183 After the Party 1979

Screenprint, 21^1/$_2$" x 30^1/$_2$" (54.6 x 77.5 cm), printed on Arches 88.
Edition: 1,000, 30 AP, 3 PP, 10 HC, signed and numbered
in pencil lower right.
Included with the Gold Edition of *Exposures* by Andy Warhol,
Grosset and Dunlap, Inc., 1979.
Printer: Rupert Jasen Smith, New York
Publisher: Grosset and Dunlap, Inc., New York

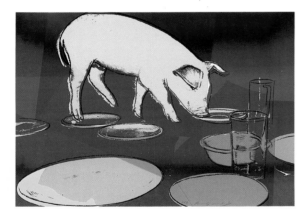

184 Fiesta Pig 1979

Screenprint, 21^1/$_2$" x 30^1/$_2$" (54.6 x 77.5 cm),
printed on Arches 88.
Edition: 200, 10 AP, 5 PP which are trial proof
variations, 1 HC, signed and numbered in pencil lower right.
Printer: Rupert Jasen Smith, New York
Publisher: Axel Springer Verlag, Hamburg

185 U.N. Stamp 1979

Offset lithograph, 8^1/$_2$" x 11" (21.6 x 27.9 cm),
image 7" x 8^1/$_2$" (17.8 x 21.6 cm), printed on Rives.
This philatelic art print has a stamp with a first day cover cancellation
done to accompany a new issue of United Nations stamps.
Edition: 1,000, signed very large in felt pen vertically along
the right margin and numbered in pencil lower center.
There is also a small printed signature lower right.
Five-hundred have a U.S. stamp, and five-hundred have a Swiss stamp.
There were 25,000 first day cover envelopes printed with
either U.S. stamps, Swiss stamps or both stamps.
Published to raise funds for the educational programs
of the World Federation of United Nations Associations.
Printer: United Nations
Publisher: United Nations Disaster Relief Organization

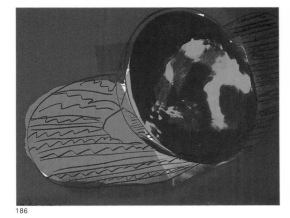
186

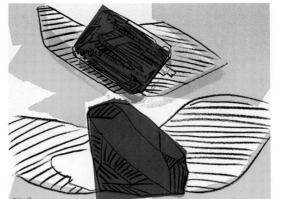
187

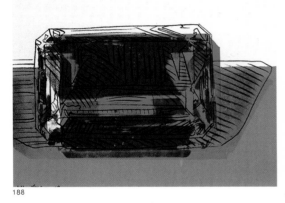
188

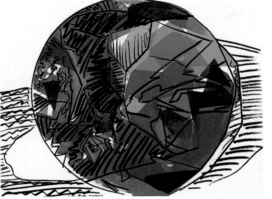
189

186 – 189 Gems 1978

Portfolio of four screenprints, 30" x 40" (76.2 x 101.6 cm), printed on Strathmore.
Edition: 20, 5 AP, 1 PP, 2 PP numbered in Roman numerals, signed and numbered in felt
pen lower left except #189 lower center.
#186, #187, #188 are executed in four variations (two half-tone variations and one
with the drawing line, one without the drawing line). #189 are all the same.
Portfolios are assembled with mixed variations.
Printer: Rupert Jasen Smith, New York
Publisher: Andy Warhol Enterprises, Inc., New York

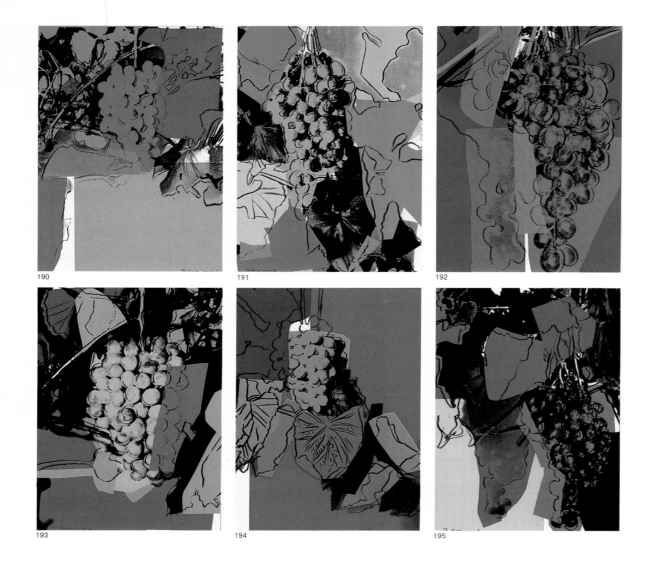

190 191 192

193 194 195

190 – 195 Grapes 1979

Portfolio of six screenprints, 40" x 30" (101.6 x 76.2 cm), printed on Strathmore.
Edition: 50, 10 AP, 2 PP, 1 HC, signed and numbered in felt pen as follows:
#190, #192, #194 lower right; #191, #193, #195 lower left.
There is also a portfolio called *Grapes D. D.* which has fine diamond dust over transparent burgundy or cobalt ink.
Edition: 4 numbered in Roman numerals, 1 PP in Arabic, signed and numbered in felt pen.
Printer: Rupert Jasen Smith, New York
Publisher: Andy Warhol Enterprises, Inc., New York

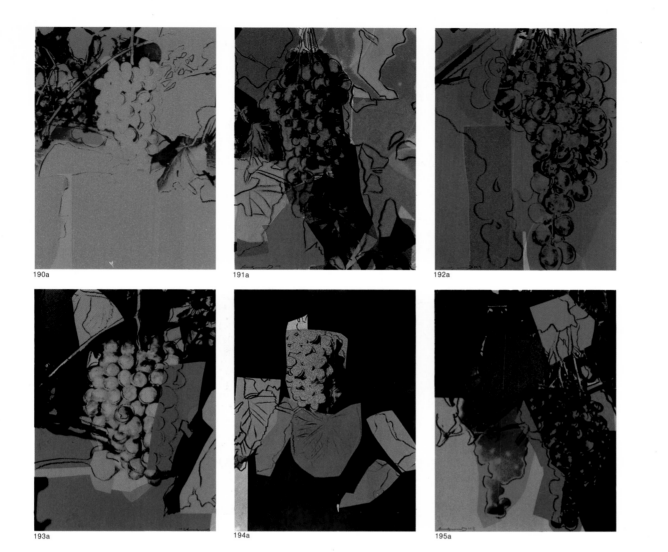

190a – 195a Grapes (Special Edition) 1979

Portfolio of six screenprints, 40" x 30" (101.6 x 76.2 cm), printed on Strathmore.
It is the same as *Grapes D. D.* but does not have diamond dust and also has carmine ink.
Edition: 10, 1 PP, signed and numbered in felt pen as follows: #190a, #193a, #194a lower right;
#191a, #192a, #195a lower left. SE is marked before all the numbers i.e. SE 1/10, SEPP 1/1.
Printer: Rupert Jasen Smith, New York
Publisher: Andy Warhol Enterprises, Inc., New York

196　　Space Fruit: Lemons　　1978

197　　Space Fruit: Oranges　　1978

Two screenprints, 30" x 40" (76.2 x 101.6 cm),
printed on Strathmore.
Edition: 10, 1 PP, signed and numbered
lower left, #196 in felt pen, #197 in pencil.
Printer: Rupert Jasen Smith, New York
Publisher: Andy Warhol Enterprises, Inc., New York

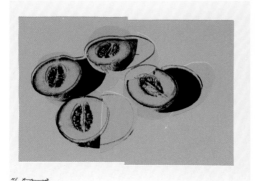

198 Cantaloupes II

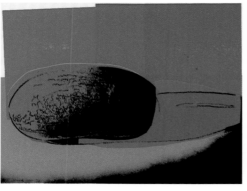

199 Watermelon

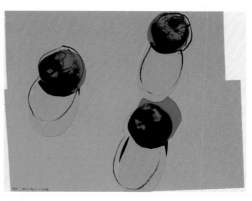

200 Apples

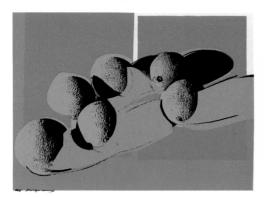

201 Cantaloupes I

202 Peaches

203 Pears

198 – 203 Space Fruit: Still Lifes 1979

Portfolio of six screenprints, 30" x 40" (76.2 x 101.6 cm), printed on two-ply Lenox Museum Board.
Edition: 150, 1 PP on Strathmore, signed and numbered in felt pen lower left. There are 30 numbered
in Roman numerals on four-ply Lenox Museum Board, signed and numbered in pencil as follows:
#198, #201, #202 lower right; #199, #200, #203 lower left.
Printers: Rupert Jasen Smith and Joe Grippi, New York
Publisher: Michael Zivian, New York

204 – 209 Shadows I 1979

Portfolio of six screenprints with diamond dust, 43" x 30¹/₂" (109.2 x 77.5 cm), printed on Arches 88.
Edition: 15, 2 AP, 1 PP, 1 HC, signed and numbered in pencil on verso.
There are six different brushmarked backgrounds (yellow, red, blue, pink, silver, gold)
with six different diamond dusted images. Portfolios are assembled with mixed variations.
Printer: Rupert Jasen Smith, New York
Publisher: Andy Warhol, New York

210 – 215 Shadows II 1979

Portfolio of six screenprints with diamond dust, 43" x 30$^1/_2$" (109.2 x 77.5 cm), printed on Arches 88.
Edition: 10, 1 AP, signed and numbered in pencil on verso.
There are six different backgrounds without brushmarks (yellow, red, blue, pink, silver, gold)
with six different diamond dusted images. Portfolios are assembled with mixed variations.
Printer: Rupert Jasen Smith, New York
Publisher: Andy Warhol, New York

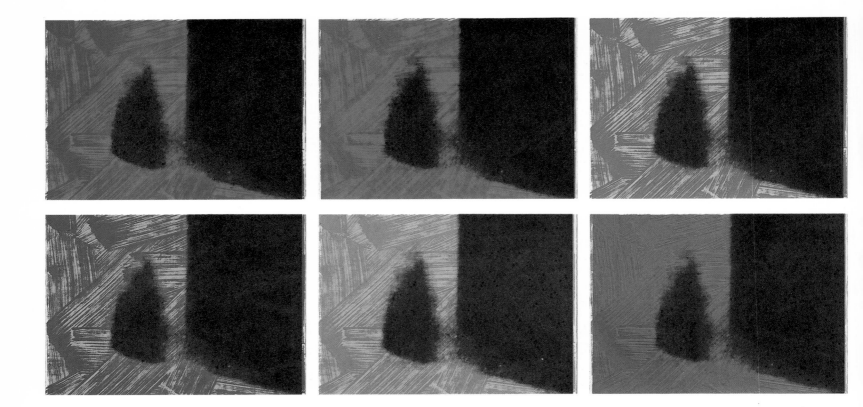

216 – 221 Shadows III 1979

Portfolio of six screenprints with diamond dust, 30¹/₂" x 43" (77.5 x 109.2 cm), printed on Arches 88.
Edition: 3, signed and numbered in pencil on verso. Each of the 18 prints has a uniquely colored brushmarked background with the same image.
Printer: Rupert Jasen Smith, New York
Publisher: Andy Warhol, New York

224 – 225 Shadows V 1979

Portfolio of two screenprints with diamond dust,
43" x 30¹/₂" (109.2 x 77.5 cm), printed on Arches 88.
Edition: 10, 1 PP, 6 HC, signed and numbered in pencil on verso.
There is at least one signed print marked HC without a number.
There are six different brushmarked backgrounds (yellow, red,
blue, pink, silver, gold) with six different diamond dusted images.
Portfolios are assembled with mixed variations.
Printer: Rupert Jasen Smith, New York
Publisher: Andy Warhol, New York

222 – 223 Shadows IV 1979

Portfolio of two screenprints with diamond dust,
30¹/₂" x 43" (77.5 x 109.2 cm), printed on Arches 88.
Edition: 10, signed and numbered in pencil on verso.
There are ten negative/positive background colors.
Each portfolio contains a negative/positive in
the same color.
Printer: Rupert Jasen Smith, New York
Publisher: Andy Warhol, New York

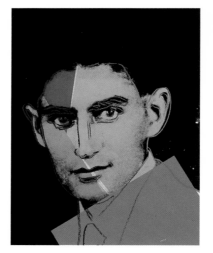

226 Franz Kafka

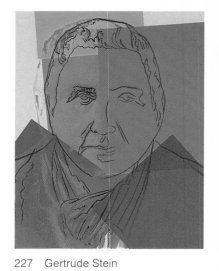

227 Gertrude Stein

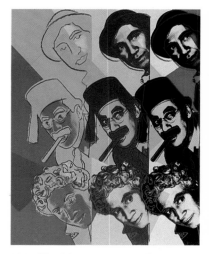

231 George Gershwin

232 The Marx Brothers

226 – 235 Ten Portraits of Jews of the Twentieth Century
1980

Portfolio of ten screenprints and colophon,
40" x 32" (101.6 x 81.2 cm),
printed on Lenox Museum Board.

228 Martin Buber

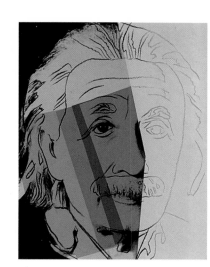

229 Albert Einstein

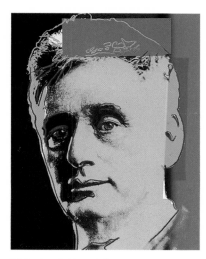

230 Louis Brandeis

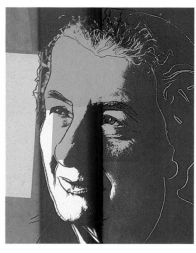

233 Golda Meir

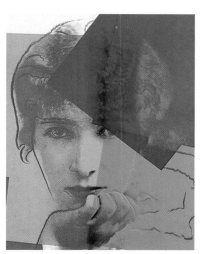

234 Sarah Bernhardt

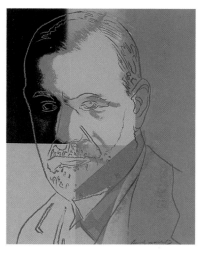

235 Sigmund Freud

Edition: 200, 30 AP, 5 PP, 3 EP, 25 TP, signed and numbered in pencil
as follows: Bernhardt, Buber, Freud, Gershwin, Meir, Stein lower right;
Brandeis, Einstein, Kafka and The Marx Brothers lower left. The colophon is signed lower right.
Printer: Rupert Jasen Smith, New York
Publishers: Ronald Feldman Fine Arts, Inc., New York; Jonathan A Editions, Tel Aviv

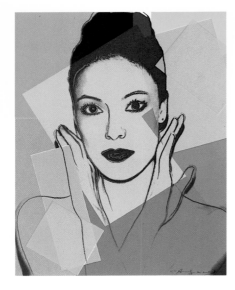

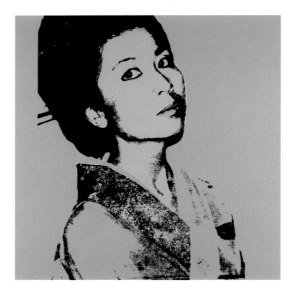

236 Karen Kain 1980

Screenprint with diamond dust, 40" x 32"
(101.6 x 81.2 cm), printed on Lenox Museum Board.
Edition: 200, 30 AP, 5 PP, 25 TP, signed and numbered
in pencil lower right. The edition of 200 is also signed
in pencil by Karen Kain, a Canadian ballerina.
Printer: Rupert Jasen Smith, New York
Publisher: Will Hector, Toronto

237 Kimiko 1981

Screenprint, 36" x 36" (91.5 x 91.5 cm),
printed on Stonehenge.
Edition: 250, 50 AP, signed and numbered in pencil on
verso. Published to raise funds for a special Visual Arts
Program sponsoring visiting artists and exhibitions at
Colorado State University.
Printer: Licht Editions, Ltd., Denver
Publisher: Colorado State University, Department of
Art, Fort Collins

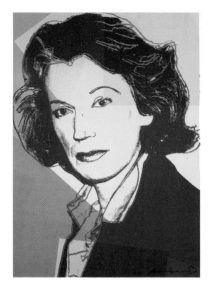

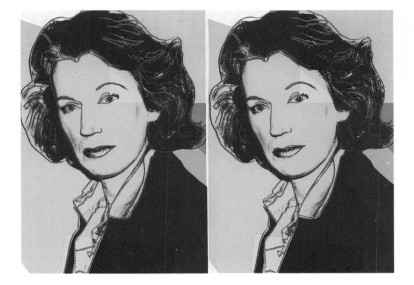

238 Mildred Scheel 1980

Screenprint with diamond dust, 30$\frac{1}{2}$" x 21$\frac{1}{2}$" (77.5 x 54.6 cm),
printed on Arches 88.
Edition: 1,000, 5 HC, signed and numbered in pencil lower right.
It is also signed in felt pen by Mildred Scheel, the President of the
German Cancer Society. Published to raise funds for the
German Cancer Society.
Printer: Rupert Jasen Smith, New York
Publisher: Deutsche Krebshilfe e.V., Cologne

239 Mildred Scheel 1980

Screenprint with diamond dust, 30$\frac{1}{2}$" x 43" (77.5 x 109.2 cm),
printed on Arches 88.
Edition: 50 AP, 5 PP which are trial proof variations, 15 TP,
signed and numbered in pencil lower right.
Printer: Rupert Jasen Smith, New York
Publisher: Deutsche Krebshilfe e.V., Cologne

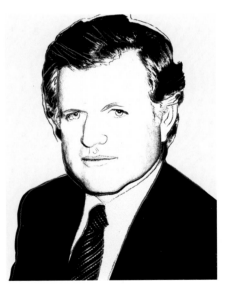

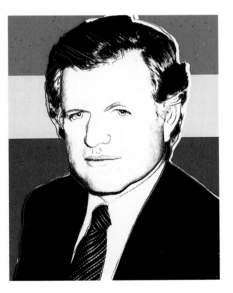

240 Edward Kennedy 1980

Screenprint with diamond dust, 40" x 32"
(101.6 x 81.2 cm), printed on Lenox Museum Board.
Edition: 300, 25 AP, 3 PP, 10 HC which are trial proof variations,
15 TP, 1 TPPP, signed and numbered in pencil lower right.
Published to raise funds for the Edward Kennedy primary
campaign for President.
Printer: Rupert Jasen Smith, New York
Publisher: Committee to Elect Edward Kennedy

241 Edward Kennedy (Deluxe Edition) 1980

Screenprint with diamond dust, 40" x 32"
(101.6 x 81.2 cm), printed on Lenox Museum Board.
Edition: 50, 15 AP, 1 PP, signed and numbered in pencil lower
right. DE is marked before all the numbers i.e.
DE 1/50, DEAP 1/15, DEPP 1/1.
Published to raise funds for the Edward Kennedy primary
campaign for President.
Printer: Rupert Jasen Smith, New York
Publisher: Committee to Elect Edward Kennedy

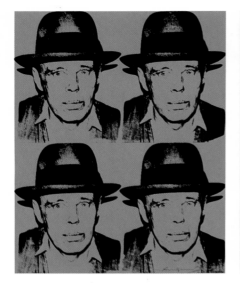 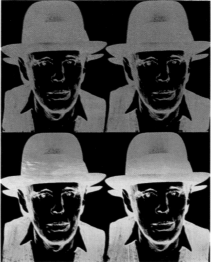 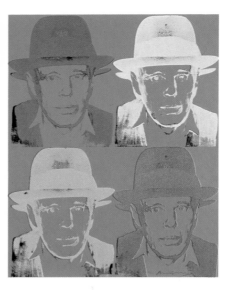

242 State I 243 State II 244 State III

242 – 244 Joseph Beuys 1980/83

Screenprint in three states, 40" x 32" (101.6 x 81.2 cm), printed on Lenox Museum Board.
States II and III have rayon flock.
Edition: 150, 36 AP, 9 PP, 45 TP, signed and numbered in pencil lower right.
State I, 1980: 50 numbered 101–150, AP 25/36–36/36, PP 7/9–9/9;
State II, 1980/83: 50 numbered 51–100, AP 13/36–24/36, PP 4/9–6/9;
State III, 1980/83: 50 numbered 1–50, AP 1/36–12/36, PP 1/9–3/9.
Printer: Rupert Jasen Smith, New York
Publisher: Editions Schellmann & Klüser, Munich/New York

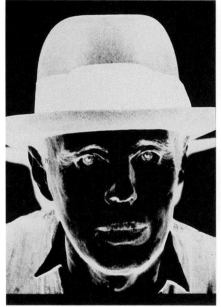
245

246

247

245 – 247　Joseph Beuys　1980

Portfolio of three screenprints, 44" x 30" (111.8 x 76.2 cm), printed on Black Arches.
#245 and #247 have diamond dust.
Edition: 90, 15 AP, 3 PP, a total of 13 individual TP not in portfolios numbered TP 1/3 – 3/3 and TP 1/10 – 10/10,
signed and numbered in pencil lower right.
Printer: Rupert Jasen Smith, New York
Publisher: Editions Schellmann & Klüser, Munich/New York

248 – 252 Shoes (Deluxe Edition) 1980

Portfolio of five screenprints with diamond dust, 40¼" x 59½" (102.2 x 151.2 cm),
printed on D'Arches Watercolor (Cold Press).
Edition: 10, 1 PP, signed and numbered in pencil on verso. DE is marked after each number i.e. 1/10 DE, PP 1/1 DE.
Printer: Rupert Jasen Smith, New York
Publisher: Andy Warhol, New York

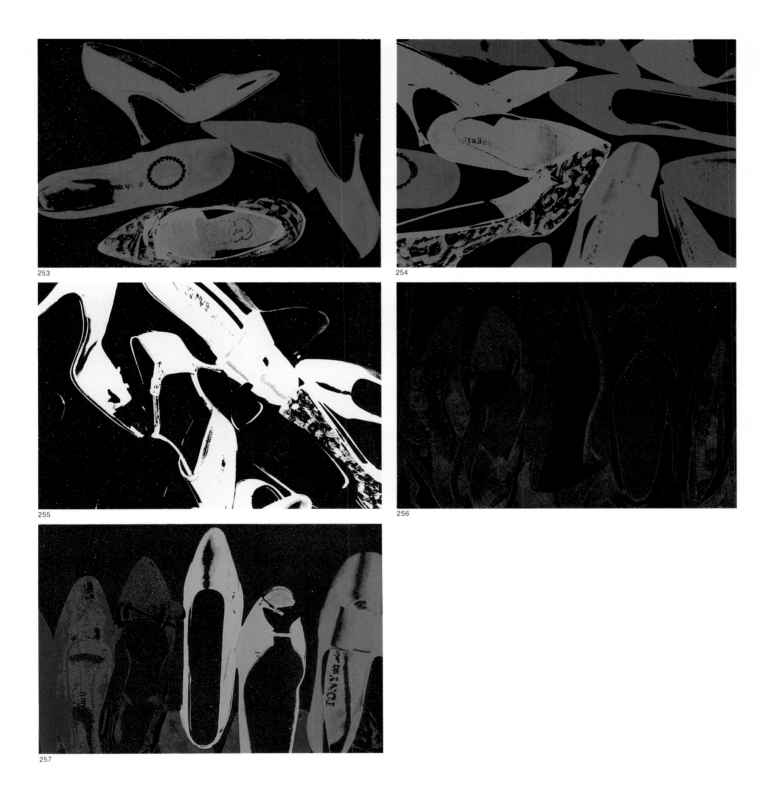

253 – 257 Shoes 1980

Portfolio of five screenprints with diamond dust, 40¼" x 59½" (102.2 x 151.2 cm),
printed on D'Arches Watercolor (Cold Press).
Edition: 60, 10 AP, 2 PP, signed and numbered in pencil on verso.
Printer: Rupert Jasen Smith, New York
Publisher: Andy Warhol, New York

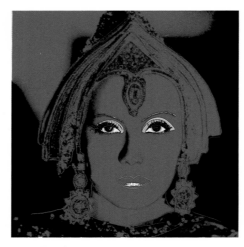
258 The Star

259 Uncle Sam

263 Howdy Doody

264 Dracula

258 – 267 Myths 1981

Portfolio of ten screenprints and colophon, 38" x 38" (96.5 x 96.5 cm),
printed on Lenox Museum Board.
All prints have diamond dust except Dracula.
Edition: 200, 30 AP, 5 PP, 5 EP, 30 TP. The following HC copies
are numbered separately for each image: 1 Dracula, 3 Howdy Doody,

260 Superman

261 The Witch

262 Mammy

 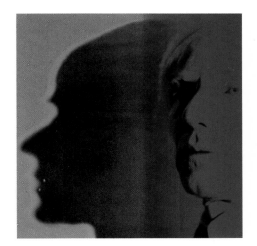

265 Mickey Mouse

266 Santa Claus

267 The Shadow

4 Mammy, 4 Mickey Mouse, 1 Santa Claus, 1 The Shadow, 4 The Star, 12 Superman, 1 Uncle Sam, 10 The Witch.
All prints are signed and numbered in pencil as follows: The Star, Howdy Doody
and The Witch signed on verso; Dracula, Mammy, Santa Claus, Superman,
The Shadow and Uncle Sam lower right; Mickey Mouse lower left. The colophon is unsigned.
Printer: Rupert Jasen Smith, New York
Publisher: Ronald Feldman Fine Arts, Inc., New York

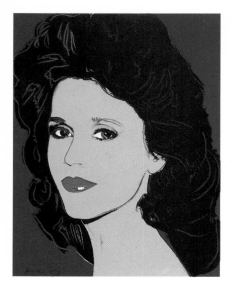

268 Jane Fonda 1982

Screenprint, 39¹/₂" x 31¹/₂" (100.3 x 80 cm),
printed on Lenox Museum Board.
Edition: 100, 20 AP, 3 PP, 25 TP, signed and numbered
in pencil lower left.
Published to raise funds for the Tom Hayden campaign
for California State Assemblyman.
Printer: Rupert Jasen Smith, New York
Publisher: Friends of Tom Hayden

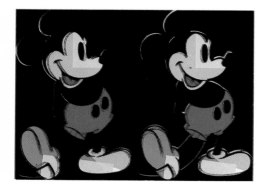

269 Double Mickey Mouse 1981

Screenprint, 30¹/₂" x 43" (77.5 x 109.2 cm),
printed on Arches 88.
Edition: 25 unique prints, some of which have
diamond dust, signed and numbered in pencil on verso.
Printer: Rupert Jasen Smith, New York
Publisher: Ronald Feldman Fine Arts, Inc., New York

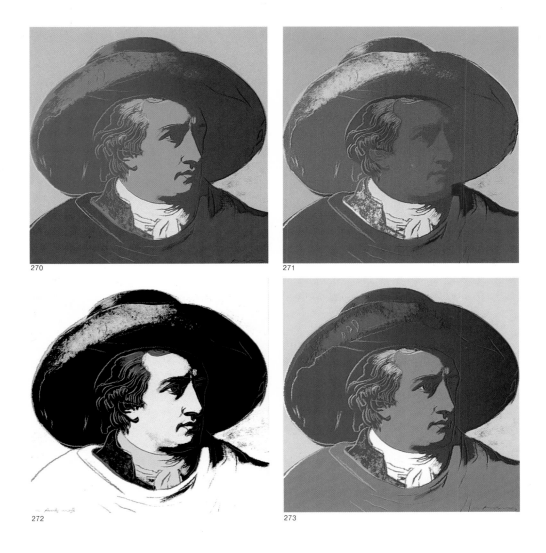

270 | 271
272 | 273

270 – 273 Goethe 1982

Portfolio of four screenprints, 38" x 38" (96.5 x 96.5 cm),
printed on Lenox Museum Board.
Edition: 100, 22 AP, 5 PP, 2 EP, 6 HC (3 which are numbered in Roman numerals),
15 TP, signed and numbered in pencil lower right except #272 lower left.
All AP prints signed lower left and HC prints lower right.
Printer: Rupert Jasen Smith, New York
Publishers: Editions Schellmann & Klüser, Munich/New York;
Denise René/Hans Mayer, Düsseldorf

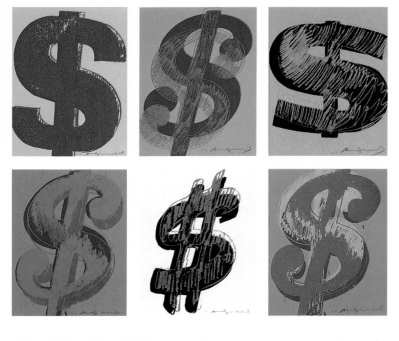

274 – 279 $1 1982

Portfolio of six screenprints, 19¾" x 15¹¹⁄₁₆" (50.2 x 39.9 cm),
printed on Lenox Museum Board.
Each $ image is unique in color.
Edition: 60, 10 AP, 3 PP, 15 TP, signed and numbered in pencil lower right.
Printer: Rupert Jasen Smith, New York
Publisher: Andy Warhol, New York

280 $1 1982

Screenprint, 20" x 16" (50.8 x 40.6 cm), printed on Lenox Museum Board.
Edition: 25 unique prints, signed and numbered in pencil lower right.
Printer: Rupert Jasen Smith, New York
Publisher: Andy Warhol, New York

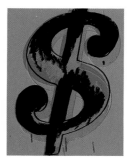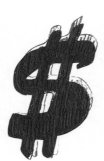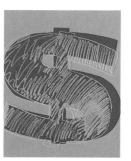

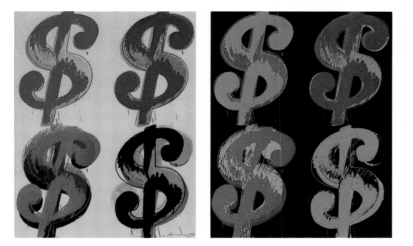

281 – 282 $4 1982

Portfolio of two screenprints, 40" x 32" (101.6 x 81.2 cm), printed on Lenox Museum Board. There are seven background colors (white, yellow, chartreuse, red, cerise, turquoise, black). Portfolios contain two color variations.
Each $ image is unique in color.
Edition: 35, 10 AP, 2 PP, signed and numbered in pencil lower right.
Printer: Rupert Jasen Smith, New York
Publisher: Andy Warhol, New York

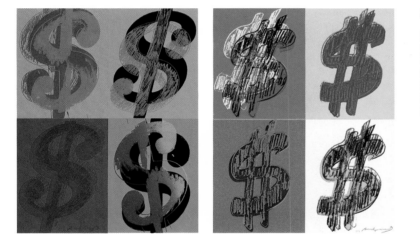

283 – 284 Quadrant $ 1982

Portfolio of two screenprints, 40" x 32" (101.6 x 81.2 cm), printed on Lenox Museum Board.
Each $ image is unique in color.
Edition: 60, 10 AP, 3 PP; #283 signed and numbered in pencil lower center, #284 lower right.
Printer: Rupert Jasen Smith, New York
Publisher: Andy Warhol, New York

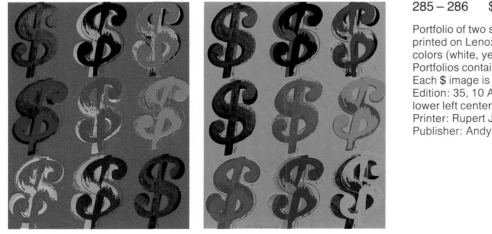

285 – 286 $9 1982

Portfolio of two screenprints, 40" x 32" (101.6 x 81.2 cm), printed on Lenox Museum Board. There are seven background colors (white, yellow, chartreuse, red, cerise, turquoise, black). Portfolios contain two color variations.
Each $ image is unique in color.
Edition: 35, 10 AP, 2 PP, signed and numbered in pencil lower left center.
Printer: Rupert Jasen Smith, New York
Publisher: Andy Warhol, New York

287 Eric Emerson (*Chelsea Girls*)
 1982

Screenprint, 30" x 22" (76.2 x 55.9 cm),
image 19" x 13" (48.2 x 33 cm),
printed on Somerset Satin White.
Edition: 75, 13 AP, 24 HC, signed and
numbered in pencil lower right.
Published in *A Portfolio of Thirteen Prints* by
thirteen artists to commemorate the
conversion of New York City's Second Avenue
Court House into the new home of Anthology
Film Archives, the first museum dedicated
to avant-garde film and video.
Printer: Porter-Wiener Studio, New York
Publisher: Anthology Film Archives, New York

288 Watercolor Paintkit with Brushes 1982

Offset lithograph, 9" x 12" (22.8 x 30.5 cm),
printed on Carnival Felt Cover.
Edition: 500, 75 AP, 5 PP, signed in felt pen lower right and
numbered in pencil lower left.
Published to raise funds for the New York Association
for the Blind.
Printers: Kordett Color Graphics and Rupert Jasen Smith, New York
Publisher: The New York Association for the Blind

289 Committee 2000
 1982

Screenprint, 30" x 20"
(76.2 x 50.8 cm), printed
on Lenox Museum Board.
Edition: 2,000, 200 AP, 25 PP,
50 HC, 5 TP which are not
unique but the same as the
edition, signed and numbered
in pencil lower right.
Published to raise funds for
the Committee 2000 which is
working on projects to
commemorate the year 2000.
Printer: Rupert Jasen Smith,
New York
Publisher: Committee 2000,
Munich

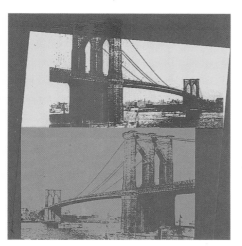

290 Brooklyn Bridge 1983

Screenprint, 39¼" x 39¼" (99.7 x 99.7 cm), printed on Lenox Museum Board.
Edition: 200, 20 AP, 5 PP, 25 TP, 10 HC. There are 5 signed and unnumbered TPs.
Prints numbered 176–200 signed horizontally lower left in pencil; all others signed vertically
lower left margin in pencil. All prints are numbered in pencil lower left.
Created at the invitation of the 1983 Brooklyn Bridge Centennial Commission, Inc. to
commemorate the 100th Anniversary of the Brooklyn Bridge.
Printer: Rupert Jasen Smith, New York
Publisher: The 1983 Brooklyn Bridge Centennial Commission, Inc., New York

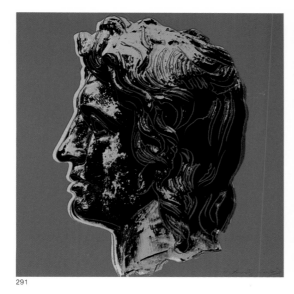
291

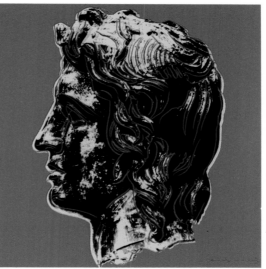
292

291 – 292 Alexander the Great 1982

Portfolio of two screenprints, 39¹/₂" x 39¹/₂" (100.3 x 100.3 cm),
printed on Lenox Museum Board.
Edition: 25, 5 AP, 1 PP, signed and numbered in pencil lower right.
There are the following signed and numbered individual trial proofs not in portfolios:
65 TP, 40" x 40" (101.6 x 101.6 cm); 15 TP, 39¹/₂" x 39¹/₂" (100.3 x 100.3 cm);
8 TP numbered in Roman numerals, 40" x 32" (101.6 x 81.2 cm);
5 TPAP, 40" x 40" (101.6 x 101.6 cm).
Published in cooperation with the Hellenic Heritage Foundation to coincide
with *The Search for Alexander* exhibition at the Metropolitan Museum of Art in New York.
Printer: Rupert Jasen Smith, New York
Publisher: Alexander Iolas, New York

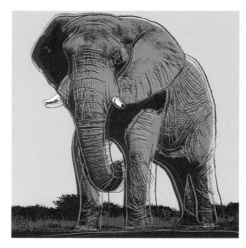

293 African Elephant

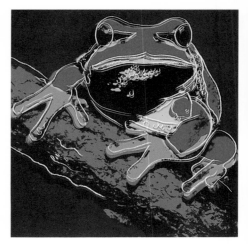

294 Pine Barrens Tree Frog

298 San Francisco Silverspot

299 Orangutan

293 – 302 Endangered Species 1983

Portfolio of ten screenprints and colophon, 38" x 38" (96.5 x 96.5 cm), printed on Lenox Museum Board.
Edition: 150, 30 AP, 5 PP, 5 EP, 3 HC presented to collaborators,
10 numbered in Roman numerals presented to wildlife organizations,

295 Giant Panda

296 Bald Eagle

297 Siberian Tiger

300 Grevy's Zebra

301 Black Rhinoceros

302 Bighorn Ram

1 Bon À Tirer, 30 TP, signed and numbered in pencil as follows: African Elephant, Orangutan,
San Francisco Silverspot lower right; Black Rhinoceros, Giant Panda, Pine Barrens Tree Frog, Siberian Tiger,
Bald Eagle lower left; Bighorn Ram and Grevy's Zebra lower center. The colophon is unsigned.
Printer: Rupert Jasen Smith, New York
Publisher: Ronald Feldman Fine Arts, Inc., New York

303 Speed Skater 1983

Screenprint, 33½" x 24⅞⁶" (85.1 x 62.2 cm), printed on Arches 88.
Edition: 150, 10 AP, 2 PP, signed and numbered in Roman
numerals in pencil lower right.
There is also a Deluxe Edition printed on D'Arches Watercolor
(Cold Press), 33⅜" x 24⅛" (84.7 x 61.2 cm).
Edition: 50, 10 AP, 2 PP, signed and numbered in pencil lower right.
There are the following signed and numbered trial proofs:
15 TP, 34⅛" x 24½" (86.6 x 62.2 cm);
15 TP lettered A-O, 40⅝" x 26" (103.2 x 66 cm);
6 TP numbered in Roman numerals, 40⅝" x 29¼" (103.2 x 74.2 cm).
Published in *Art and Sports* containing works by seventeen artists,
the official art portfolio of the XIV Olympic Winter Games in Sarajevo,
Yugoslavia.
Printer: Rupert Jasen Smith, New York
Publisher: Visconti Art Spectrum, Vienna

304 Sidewalk 1983

Screenprint, 29" x 42" (73.7 x 106.7 cm),
printed on Dutch Etching.
Edition: 250, 30 AP, 6 PP, 15 HC, 45 TP, 3 TPPP,
signed and numbered in pencil lower left. The TP and TPPP prints are
on untrimmed paper, 30" x 44¹/₂" (76.2 x 113 cm).
Published in a portfolio containing works by eight artists,
Eight by Eight to Celebrate the Temporary Contemporary,
to raise funds for the new museum in Los Angeles.
Printer: Rupert Jasen Smith, New York
Publisher: The Museum of Contemporary Art, Los Angeles

305 Grace Kelly 1984

Screenprint, 40" x 32" (101.6 x 81.2 cm),
printed on Lenox Museum Board.
Edition: 225, 50 numbered in Roman numerals, 30 AP, 8 PP,
2 HC, 20 TP, signed and numbered in pencil lower left.
Published to raise funds for the Institute of Contemporary Art
in Philadelphia.
Printer: Rupert Jasen Smith, New York
Publisher: Institute of Contemporary Art, University of
Pennsylvania, with the consent of the Princess Grace
Foundation, U.S.A.

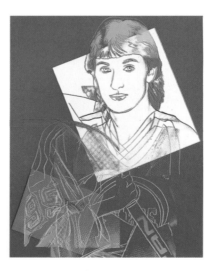

306 Wayne Gretsky #99 1984

Screenprint, 40" x 32" (101.6 x 81.2 cm),
printed on Lenox Museum Board.
Edition: 300, 50 AP, 6 PP which are trial proof variations,
signed and numbered in pencil lower left.
There will be a Roman numeral Deluxe Edition
of approximately 50 prints based on a trial proof variation.
Printer: Rupert Jasen Smith, New York
Publisher: Frans Wynans, Vancouver

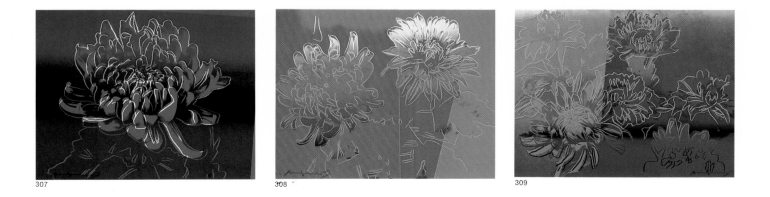

307 308 309

307 – 309 Kiku 1983

Three screenprints, 19⅝" x 26" (50 x 66 cm), printed on Rives BFK.
Edition: 300, 30 AP, 3 PP, 5 EP, #307 18 HC, # 308 15 HC, #309 17 HC, signed and numbered in pencil lower left.
Printers: Rupert Jasen Smith, New York; Ryoichi Ishida, Tokyo
Publisher: Gendai Hanga Center, Tokyo

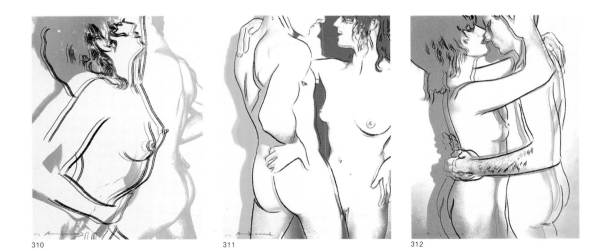

310 311 312

310 – 312 Love 1983

Three screenprints, 26" x 19⅝" (66 x 50 cm), printed on Rives BFK.
Edition: 100, 10 AP, 2 PP, 5 EP, #310 7 HC, #311 16 HC, #312 17 HC, signed and numbered in pencil lower left.
Printers: Rupert Jasen Smith, New York; Ryoichi Ishida, Tokyo
Publisher: Form K.K., Tokyo

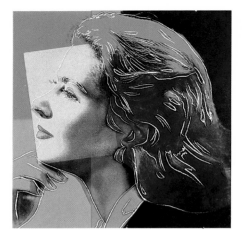

313 Herself

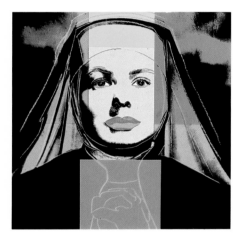

314 The Nun

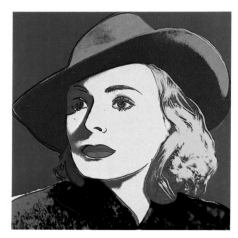

315 With Hat

313 – 315 Ingrid Bergman 1983

Portfolio of three screenprints, 38" x 38" (96.5 x 96.5 cm), printed on Lenox Museum Board.
Edition: 250, 20 AP, 5 PP, 30 HC, 30 TP, signed and numbered in pencil lower right.
Printer: Rupert Jasen Smith, New York
Publisher: Galerie Börjeson, Malmö

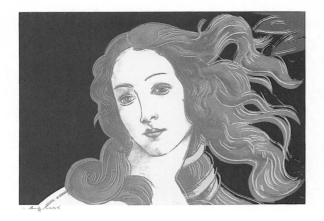

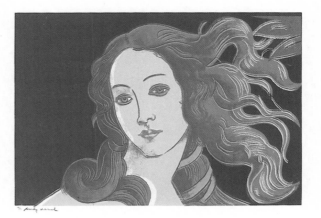

316

317

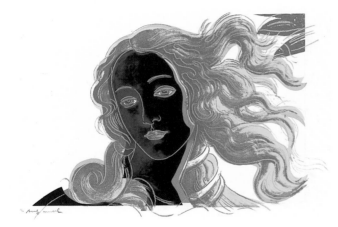

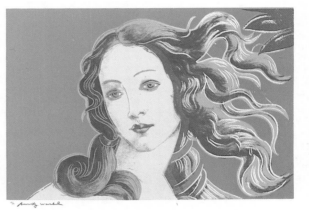

318

319

316 – 319 Details of Renaissance Paintings (Sandro Botticelli, *Birth of Venus,* 1482) 1984

Portfolio of four screenprints, 32" x 44" (81.2 x 111.8 cm), image 25" x 37" (63.5 x 94 cm),
printed on D'Arches Watercolor (Cold Press).
Edition: 70, 18 AP, 5 PP, 5 HC, signed and numbered in pencil lower left margin.
There are 36 TP portfolios containing one image from each of the *Details* portfolios and one image
based on Piero della Francesca's *Madonna del Duca da Montefeltro,* circa 1472.
Printer: Rupert Jasen Smith, New York
Publisher: Editions Schellmann & Klüser, Munich/New York

320

321

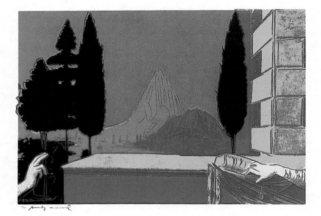

322

323

320 – 323 Details of Renaissance Paintings (Leonardo da Vinci, *The Annunciation,* 1472) 1984

Portfolio of four screenprints, 32" x 44" (81.2 x 111.8 cm), image 25" x 37" (63.5 x 94 cm),
printed on D'Arches Watercolor (Cold Press).
Edition: 60, 15 AP, 5 PP, 4 HC, signed and numbered in pencil lower left margin.
There are 36 TP portfolios as described in #316–319.
Printer: Rupert Jasen Smith, New York
Publisher: Editions Schellmann & Klüser, Munich/New York

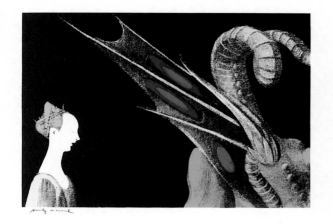

324

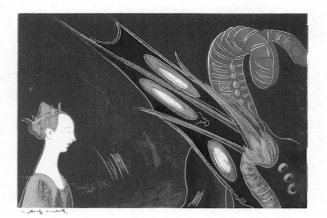

325

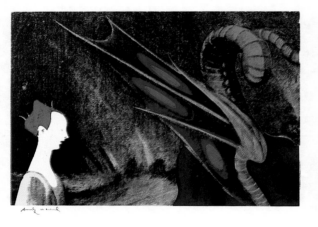

326

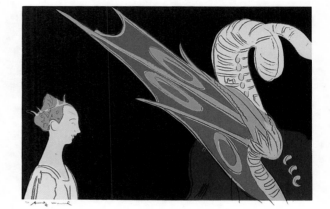

327

324 – 327 Details of Renaissance Paintings (Paolo Uccello, *St. George and the Dragon,* 1460) 1984

Portfolio of four screenprints, 32" x 44" (81.2 x 111.8 cm), image 25" x 37" (63.5 x 94 cm),
printed on D'Arches Watercolor (Cold Press).
Edition: 50, 12 AP, 5 PP, 4 HC, signed and numbered in pencil lower left margin.
There are 36 TP portfolios as described in #316–319.
Printer: Rupert Jasen Smith, New York
Publisher: Editions Schellmann & Klüser, Munich/New York

328 Frederick Weisman 1984

Screenprint, 44" x 28¾" (111.8 x 73 cm),
printed on D'Arches Watercolor cut from a roll.
Edition: 24, signed and numbered in pencil lower right.
The prints, divided into four editions, all have the same
underlying colors; only the half-tone color differs.
They are numbered as follows: 1–12 (black half-tone),
1–4 (purple half-tone), 1–4 (ultra-blue half-tone),
1–4 (dark metallic green half-tone).
Printer: Rupert Jasen Smith, New York
Publisher: Andy Warhol, New York

329 Viewpoint 1984

Lithograph, 40" x 30" (101.6 x 76.2 cm), printed on Arches.
Edition: 21, signed in pencil lower right, numbered in pencil lower left.
Printer: Atelier Ettinger, New York
Publisher: Trans Atlantic Consultants, Inc., New York

330

331

332

333

330 – 333 Saint Apollonia 1984

Portfolio of four screenprints, 30" x 22" (76.2 x 55.9 cm), printed on Essex Offset Kid Finish.
Edition: 250, 35 AP, 8 PP, 80 individual TP not in portfolios, 20 individual TP not
in portfolios numbered in Roman numerals, signed and numbered in pencil lower left.
Printer: Rupert Jasen Smith, New York
Publisher: Dr. Frank Braun, Düsseldorf

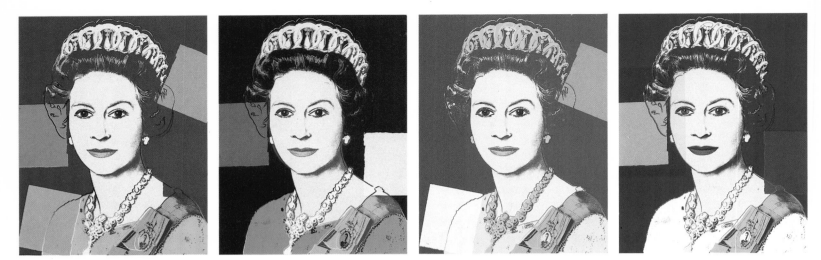

334–337 Queen Elizabeth II of the United Kingdom

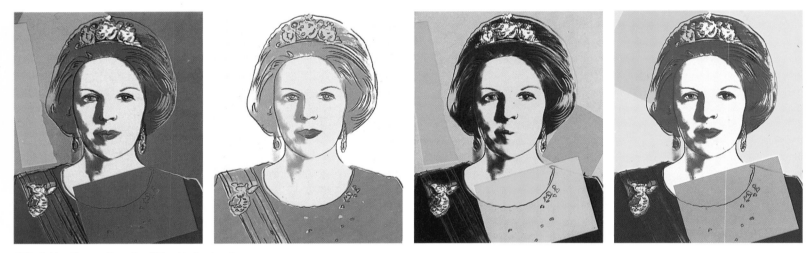

338–341 Queen Beatrix of The Netherlands

334 – 349 Reigning Queens 1985

Portfolio of sixteen screenprints, 39^1/$_2$" x 31^1/$_2$" (100.3 x 80 cm), printed on Lenox Museum Board.
Edition: 40, 10 AP, 5 PP, 3 HC, 30 TP containing only one image of each queen, signed and numbered in pencil as follows: Queen Beatrix and Queen Elizabeth lower right, Queen Margrethe and Queen Ntombi Twala lower left.

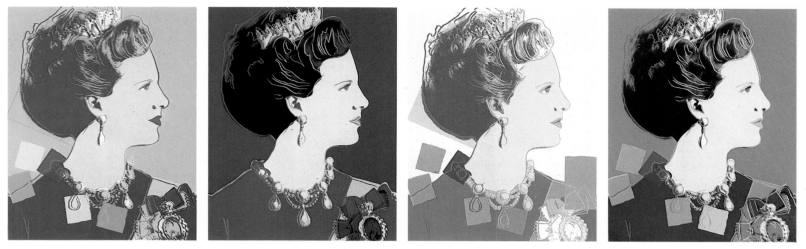

342–345 Queen Margrethe II of Denmark

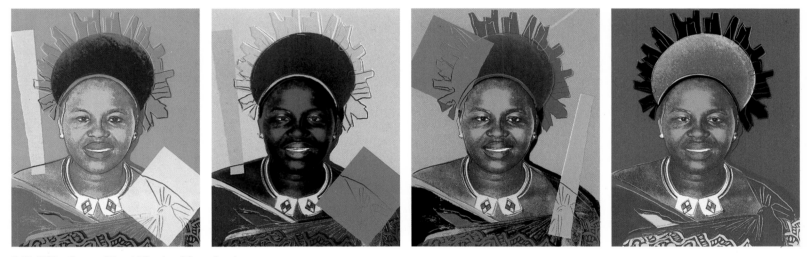

346–349 Queen Ntombi Twala of Swaziland

There is also a Royal Edition that has diamond dust on the drawing line.
Edition: 30, 5 AP, 2 PP, 2 HC, signed and numbered in pencil the same as the regular edition.
R is marked before all the numbers i.e. R 1/30, R AP 1/5, R PP 1/2, R HC 1/2.
Printer: Rupert Jasen Smith, New York
Publisher: George C. P. Mulder, Amsterdam

350 Mobil

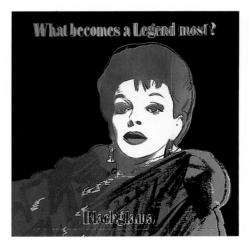

351 Blackglama (Judy Garland)

355 *Rebel Without a Cause* (James Dean)

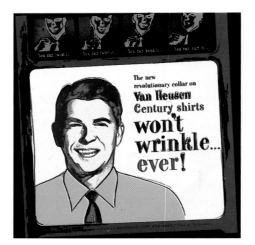

356 Van Heusen (Ronald Reagan)

350 – 359 Ads 1985

Portfolio of ten screenprints and colophon, 38" x 38" (96.5 x 96.5 cm),
printed on Lenox Museum Board.
Edition: 190, 30 AP, 5 PP, 5 EP, 10 HC presented to collaborators,
10 numbered in Roman numerals, 1 Bon A Tirer, 30 TP,
signed and numbered in pencil as follows: Apple, James Dean,

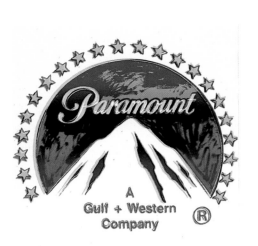

352 Paramount

353 Life Savers

354 Chanel

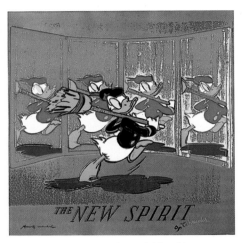

357 *The New Spirit* (Donald Duck)

358 Volkswagen

359 Apple

Ronald Reagan, Volkswagen lower right: Chanel, Donald Duck, Judy Garland,
Life Savers, Mobil, Paramount lower left. The colophon is unsigned.
There are 3 untrimmed Paramount TPHC, 40¼" x 40¼" (102.3 x 102.3 cm),
signed in pencil lower left.
Printer: Rupert Jasen Smith, New York
Publisher: Ronald Feldman Fine Arts, Inc., New York

360 Anniversary Donald Duck 1985

Screenprint, 30¹/₂" x 43" (77.5 x 109.2 cm),
printed on Arches 88.
Edition: 30 unique prints, signed and numbered
in pencil lower left
Printer: Rupert Jasen Smith, New York
Publisher: Ronald Feldman Fine Arts, Inc., New York

361 362 363 364

361 – 364 Cologne Cathedral 1985

Portfolio of four screenprints with diamond dust, 39⅝₁₆" x 31½" (100 x 80 cm),
printed on Lenox Museum Board.
Edition: 60, 15 AP, 6 PP, 15 HC, signed in pencil vertically lower right, numbered in pencil lower right.
There are 80 signed but unnumbered individual trial proofs.
Printer: Rupert Jasen Smith, New York
Publisher: Hermann Wünsche, Bonn/New York

Key to the Catalogue

Sequence: Print portfolios and single prints are arranged in chronological order wherever possible. In some instances, prints having the same image but different dates are placed side by side.

Measurements: Height precedes width in inches with metric measurements, in centimeters, given in parentheses. Measurements indicate the size of the paper. If image size is much smaller, both the image and sheet dimensions are given.

Signatures and Marks: Although sometimes the prints are signed and numbered on verso, in most instances they are signed and numbered on the front in either pencil, ball point or felt pen. All prints are numbered in Arabic numerals unless otherwise noted. Some prints are just initialled; some are also dated. Wherever possible, based on the prints we photographed, we have indicated the location of the signature and number. However, this may vary within any given edition.

All information pertaining to chopmarks of publishers, printers and paper makers and special copyright stamps, etc. appears in Appendix II pages 112–116.

Proofs: Abbreviations used in this catalogue are as follows:

AP – Artist's Proofs which are of quality equal to the edition, numbered as AP 1, etc.
In some Deluxe Editions, DEAP appears with the number.

PP – Printer's Proofs which are of quality equal to the edition, numbered as PP 1, etc.
In some Deluxe Editions, DEPP appears with the number; in some Special Editions, SEPP appears with the number.

EP – Exhibition Proofs which are of quality equal to the edition, numbered as EP 1, etc. These are prints produced for exhibition purposes.

HC – Hors Commerce prints which are of quality equal to the edition, numbered as HC 1, etc. They are often produced for collaborators.

TP – Trial Proofs which are prints pulled during the proofing process to document color changes in the edition. They are made into small editions and numbered as TP 1, etc. If there are Artist's Proofs or Printer's Proofs, TPAP or TPPP appears with the number. In most instances, we have not photographed Trial Proofs because each is a unique print, but we have documented them.

Paper: The prints described in this catalogue are printed on the following papers. If the exact paper is not known, just the color is indicated in the text.

Arches Cover – mouldmade in France, 100% rag, acid-free and buffered, watermarked

Arches 88 Silkscreen – mouldmade in France, 100% rag, made for Warhol without watermark

Black Arches – mouldmade in France, 100% rag, acid-free and buffered

Carnival Felt Cover – machine made

D'Arches Watercolor (Cold Press) or (Rough) – mouldmade in France, 100% rag, watermarked, chopmarked

Dutch Etching – mouldmade in Holland, 50% rag, acid-free

Essex Offset Kid Finish – machine made, 100% rag, acid-free

Fabriano CMF – mouldmade in Italy, 100% rag, acid-free, watermarked

J. Green – handmade, 100% rag, acid-free, watermarked

HMP – handmade, 100% rag, acid-free, watermarked

Italia – mouldmade in Italy, 50% rag, acid-free, watermarked

Lenox Museum Mounting Board (2 ply) – machine made, 100% rag, acid-free

Rives BFK – mouldmade in France, 100% rag, acid-free and buffered, watermarked

Somerset Satin White – machine made, 100% rag, acid-free, watermarked

Stonehenge – machine made, 100% rag, acid-free

Strathmore (3 ply plate) – machine made, 100% rag, chopmarked

These works are mentioned in the Editors' Note but not documented in the catalogue.

The Kiss (Bela Lugosi), 1963. Screenprint, 30" x 40" (76.2 x 101.6 cm), printed on white paper. Based on a photograph from the film *Dracula*, 1931 with Bela Lugosi and Helen Chandler.

Cagney, 1964. Screenprint, 30" x 40" (76.2 x 101.6 cm), printed on white paper. Based on a photograph from the film *The Public Enemy*, 1931 with James Cagney, Jean Harlow, Joan Blondell and Mae Clark.

Suicide, 1964. Screenprint, 40" x 30" (101.6 x 76.2 cm), printed on white paper.

Large Sleep, 1965. Screenprint on plexiglas, 65" x 36" (165 x 91.5 cm). The image is John Giorno sleeping.

Kiss, 1966. Screenprint on plexiglas, 22" x 12" (56 x 30.5 cm). Based on a frame from Warhol's film *Kiss*, 1963.

Empire State Building, 1966. Screenprint on plexiglas, 22" x 12" (56 x 30.5 cm). Based on a frame from Warhol's film *Empire*, 1964.

Couch, 1966. Screenprint on plexiglas, 22" x 12" (56 x 30.5 cm). Based on a frame from Warhol's film *Henry Geldzahler*, 1964 of Henry Geldzahler smoking a cigar.

Eat, 1966. Screenprint on plexiglas, 22" x 12" (56 x 30.5 cm). Based on a frame from Warhol's film *Eat,* 1963 of Robert Indiana eating one mushroom.

Sleep, 1966. Screenprint on plexiglas, 22" x 12" (56 x 30.5 cm). Based on a frame from Warhol's film *Sleep*, 1963.

1 Cooking Pot
Based on a newspaper advertisement.
Artists selected by Billy Klüver in the *American Avant Garde* portfolio: Brecht, D'Arcangelo, Dine, Durkee, Eisenhauer, Fisher, Goodman, Grooms, Kaprow, Indiana, Lichtenstein, Lurie, Oldenburg, Rosenquist, Segal, Stankiewicz, Thiebaud, Warhol, Watts, Whitman.

2a – 2d $1.57 Giant Size
This record includes interviews with the following artists who participated in the *Popular Image Exhibition* at the Washington Gallery of Modern Art, Washington, D.C. April-June 1963 organized by Billy Klüver and Alice Denney: Brecht, Dine, Johns, Lichtenstein, Oldenburg, Rauschenberg, Rosenquist, Warhol, Watts, Wesley, Wesselmann.

3 Birmingham Race Riot
Based on a photograph by Charles Moore.
It bears the printer's chopmark.
Artists in the *Ten Works by Ten Painters* portfolio: Gene Davis, Indiana, Kelly, Lichtenstein, Motherwell, Ortman, Poons, Reinhardt, Stella, Warhol.
There are paintings of this image.

5 Marilyn Monroe I Love Your Kiss Forever Forever
Artists in *1 ¢ Life:* Alechinsky, Appel, Baj, Branvanvelde, Davie, Dine, Fahlström, Francis, Indiana, Jensen, Jorn, Kaprow, Kimber Smith, Kogelnick, Leslie, Lichtenstein, Mitchell, Oldenburg, Ramos, Rauschenberg, Reinhardt, Riopelle, Rosenquist, Saura, Sonderborg, Ting, Warhol, Wesselmann.
There are paintings of this image.

6 Flower
Based on a photograph by Patricia Caulfield.

7 Liz
Based on a mass media photograph.

8 Kiss
Based on a frame from Andy Warhol's 1963 film, *Kiss*. Artists in the *Seven Objects in a Box* portfolio: D'Arcangelo, Dine, Lichtenstein, Oldenburg, Segal, Warhol, Wesselmann.

10 Banana
Based on the record cover for *The Velvet Underground and Nico* produced by Andy Warhol.

12 Cow
This print is executed from the same screen as #11.
© *Factory Additions 1971* is printed vertically in right margin.

13 Jackie I
Based on a 1963 mass media photograph.
Artists in the *Eleven Pop Artists I* portfolio: D'Arcangelo, Jones, Laing, Lichtenstein, Phillips, Ramos, Rosenquist, Warhol, Wesley, Wesselmann.
This image appears in *Jackie* paintings.

14 Jackie II
Based on a mass media photograph.
Artists in the *Eleven Pop Artists II* portfolio: D'Arcangelo, Jones, Laing, Lichtenstein, Phillips, Ramos, Rosenquist, Warhol, Wesley, Wesselmann.
This image appears in *Jackie* paintings.

15 Jackie III
Based on a mass media photograph.
Artists in the *Eleven Pop Artists III* portfolio: D'Arcangelo, Jones, Laing, Lichtenstein, Phillips, Ramos, Rosenquist, Warhol, Wesley, Wesselmann.
This image appears in *Jackie* paintings.

16 Self-Portrait
There are paintings of this image.

17 Portraits of the Artists
Artists in the *Ten From Leo Castelli* portfolio: Bontecou, Johns, Judd, Lichtenstein, Morris, Poons, Rauschenberg, Rosenquist, Stella, Warhol.

19 Lincoln Center Ticket
There are 500 unsigned posters using this image published by List Art Posters for Lincoln Center for the Performing Arts.

20 SAS Passenger Ticket
Based on Warhol's SAS airline ticket New York–Stockholm–New York. There are approximately 500 unsigned posters using this image.

21 Marilyn
Based on a mass media photograph.

22 – 31 Marilyn
Based on a mass media photograph.
Eight fake prints, 33¼" x 33¼" (84.5 x 84.5 cm), published in 1970 in different colors than the portfolio are stamped in black on verso *Published by Sunday B. Morning* and *Fill in your signature*. Some prints hand signed by Warhòl *This is not by me. Andy Warhol*.
There are paintings of this image.

32 – 42 Flash-November 22, 1963
Text by Phillip Greer.

44 – 53 Campbell's Soup I
There are paintings of these images.

54 – 63 Campbell's Soup II
There are paintings of these images.

64 – 73 Flowers
Based on a photograph by Patricia Caulfield.
Eight fake prints published in 1970 in different colors than the portfolio are stamped in black on verso *Published by Sunday B. Morning* and *Fill in your signature*.
There are paintings of this image.

74 – 83 Electric Chair
Based on a mass media photograph.
Stamped in black on verso © *Copyright Factory Additions Edition Bischofberger, Zurich*
There are paintings of this image.

84 Vote McGovern
It bears the publisher's chopmark and paper maker's watermark and chopmark.
Proofs are numbered RTP (Right to Print), PP II (Printer's Proofs), 16 CTP (Color Trial Proofs), 3 Gemini impressions, 1 Cancellation.

85 – 88 Sunset
© *1972* in pencil on verso.

89 Mao
Warhol's pencil drawing of Mao was Xeroxed sequentially (i. e. copy 1 was the master for copy 2, etc.). As the machine enlarged the image 1 % – 2 %, it expanded and was completely abstract at the end of the edition.
Stamped in black on verso © *Copyright 1973 by Andy Warhol*
Printed at Styria Studio.
Artists in *The New York Collection for Stockholm* portfolio: Bontecou, Breer, Chamberlain, de Maria, Dine, di Suvero, Fahlström, Flavin, Grooms, Haacke, Hay, Judd, Kelly, Le Witt, Lichtenstein, Morris, Nevelson, Noland, Oldenburg, Paik, Rauschenberg, Rivers, Rosenquist, Segal, Serra, Sonnier, Stankiewicz, Twombly, Warhol, Whitman.

90 – 99 Mao Tse-Tung
Based on the photo from the frontispiece of *Quotations from Chairman Mao Tse-Tung*.
Stamped in black on verso *Copyright* © *Andy Warhol 1972*
Printed at Styria Studio, Inc.
There are paintings of this image.

100 – 109 Flowers (Black and White)
These images were found in a wallpaper catalogue and *Interpretive Floral Designs* by A. S. Barnes, Raymond Russ Stoltz, New York, 1972.
Stamped in black on verso © *Copyright By Andy Warhol Multiples Inc. & Castelli Graphics 2, 1974.*
It bears the paper maker's chopmark and watermark.

110 – 119 Flowers (Hand Colored)
These images were found in a wallpaper catalogue and *Interpretive Floral Designs* by A. S. Barnes, Raymond Russ Stoltz, New York 1972.
Stamped in black on verso © *Copyright By Andy Warhol Multiples Inc. & Castelli Graphics 2, 1974.*
It bears the paper maker's chopmark and watermark.

Artist's proofs printed on four different papers at random: Fabriano CMF, 40¾" x 27¼" (103.5 x 69.2 cm); Arches, 41¾" x 29¾" (106 x 75.5 cm); D'Arches Watercolor (Rough), 40¼" x 25¼" (102.2 x 64.2 cm); J. Green, 40½" x 27⅜" (102.9 x 69.5 cm).

120 Untitled 12
In this screenprint, Warhol superimposed images he had previously used, such as the soup can, cow, coke bottle, brillo box and flowers.
It bears the paper maker's chopmark and watermark.
Artists in the *For Meyer Schapiro Portfolio*: Hayter, Johns, Kelly, Lieberman, Lichtenstein, Masson, Motherwell, Oldenburg, Rauschenberg, Steinberg, Stella, Warhol.

121 Paloma Picasso
Photographer: Andy Warhol
It bears the paper maker's watermark.
Artists in the *Hommage à Picasso* portfolio: Alechinsky, Arakawa, Baj, Bellmer, Beuys, Bill, Bury, Castillo, Chadwick, Chillida, Christo, Corneille, D'Arcangelo, Davie, de Kooning, Fahlström, Grieshaber, Hamilton, Hockney, Hrdlicka, Indiana, Johns, Jones, Kitaj, Kolář, Krushenick, Lam, Lichtenstein, Lipchitz, Mack, Manzù, Marini, Masson, Matta, Miró, Moore, Motherwell, Paolozzi, Pignon, Rauschenberg, Rivers, Rosenquist, Saint-Phalle, Soto, Stella, Tàpies, Télémaque, Tilson, Ting, Tinguely, Twombly, Voss, Warhol, Wotruba.

122 Marcia Weisman
Photographer: Andy Warhol
There are paintings of this image.
This screenprint was commissioned by a private collector.

123 Frederick Weisman
Photographer: Andy Warhol
There are paintings of this image.
This screenprint was commissioned by a private collector.

124 Merce Cunningham I
© *Andy Warhol 1974* in pencil on verso.
Artists in the *Cunningham I* portfolio: Cage, Johns, Morris, Nauman, Rauschenberg, Stella, Warhol.
This image appears in *Merce* paintings.

125 Merce Cunningham II
© in pencil on verso.

126 Ladies and Gentlemen
Stamp on verso *Andy Warhol dal manifesto per la mostra ai "Diamanti" di Ferrara 1975 – Edizione speciale – Tiratura 150.*

128 – 137 Ladies and Gentlemen
Photographer: Andy Warhol
© *AWE* in pencil on verso.
It bears the paper maker's watermark.

138 – 147 Mick Jagger
Photographer: Andy Warhol
Stamped in black on verso © *Seabird Editions*.
It bears the paper maker's chopmark and watermark.
There are paintings of these images.

148 Man Ray
Photographer: Andy Warhol
It bears the paper maker's chopmark.
There are paintings of this image.

149 Man Ray
Photographer: Andy Warhol

150 Jimmy Carter I
Photographer: Andy Warhol
It bears the paper maker's chopmark.
There are paintings of this image.

151 Jimmy Carter II
Photographer: Andy Warhol
Stamped in black on verso © *Andy Warhol Enterprises, Inc.*
It bears the paper maker's chopmark.

152 Jimmy Carter III
Photographer: Andy Warhol
It bears the paper maker's watermark.
Artists in the *Inaugural Portfolio*: Lawrence, Lichtenstein, Rauschenberg, Warhol, Jamie Wyeth.

153 Lillian Carter
Photographer: Andy Warhol
It bears the paper maker's chopmark.
There are paintings of this image.

154 – 155 Sachiko
Photographer: Andy Warhol
It bears the printer's chopmark and the paper maker's chopmark.
These screenprints were commissioned by a private collector.

156 Carter Burden
Photographer: Andy Warhol
It bears the paper maker's watermark.
Andy Warhol's signature taken from the masthead of *Interview* magazine is printed with the drawing line next to the tie.

157 – 160 Skulls
Photographer: Andy Warhol
It bears the paper maker's chopmark.
There are paintings of these images.

161 – 164 Hammer and Sickle
Photographer: Andy Warhol
It bears the paper maker's chopmark.
There are paintings of these images.

165 – 171 Hammer and Sickle (Special Edition)
Photographer: Andy Warhol
It bears the paper maker's chopmark.

172 – 177 Sex Parts
Photographer: Andy Warhol
Stamped in black on verso © *Andy Warhol Enterprises, Inc. 1978*
It bears the printer's chopmark and the paper maker's watermark.

178 Fellatio
Photographer: Andy Warhol
Stamped in black on verso © *Andy Warhol Enterprises, Inc. 1978*
It bears the printer's chopmark and the paper maker's watermark.

179 – 182 Muhammad Ali
Photographer: Andy Warhol
Stamped in black on verso © *Andy Warhol Enterprises, Inc. 1978.*
It bears the paper maker's chopmark.
There are paintings of these images.

183 After the Party
Photographer: Andy Warhol
It bears the printer's chopmark.
The image is printed on a half sheet of Arches with one edge machine-trimmed and the other edge deckled.

184 Fiesta Pig
Photographer: Andy Warhol
Stamped in black on verso © *Andy Warhol.*
It bears the paper maker's chopmark.
The image is printed on a half sheet of Arches with one edge machine-trimmed and the other edge deckled.
Warhol is a collector of Fiesta, colorful dishes manufactured from the '30s to the '50s. The publicity photograph used by Warhol in the late '70s and early '80s shows him holding this pig.

185 U. N. Stamp
Printed on verso: *Photo-collage by Andy Warhol (U.S.A.) World Federation of United Nations Associations Cachet Print.*

186 – 189 Gems
Photographer: Andy Warhol
Stamped in black on verso © *Andy Warhol Enterprises, Inc. 1978.*
It bears the printer's chopmark and the paper maker's chopmark.
There are paintings of these images.

190 – 195 Grapes
Photographer: Andy Warhol
Stamped in black on verso © *Andy Warhol 1979.*
It bears the printer's chopmark and the paper maker's chopmark.
Grapes D. D. has not been photographed because the diamond dust does not show up in the photographs.
This is the first time Warhol uses diamond dust in prints.

190a – 195a Grapes (Special Edition)
Photographer: Andy Warhol
Stamped in black on verso © *Andy Warhol 1979.*
It bears the printer's chopmark and the paper maker's chopmark.

196 Space Fruit: Lemons
Photographer: Andy Warhol
Stamped in black on verso © *Andy Warhol Enterprises, Inc. 1978.*
It bears the printer's chopmark and the paper maker's chopmark.
There is one unsigned and unnumbered progressive set which includes the four separate colors of the print progression plus one with only the drawing line and one with the black printer like the edition in registration with the drawing line.

197 Space Fruit: Oranges
Photographer: Andy Warhol
Stamped in black on verso © *Andy Warhol Enterprises, Inc. 1978.*
It bears the printer's chopmark and the paper maker's chopmark.
There is one unsigned and unnumbered progressive set which includes the two separate colors of the print progression plus one with only the drawing line and one with the black printer like the edition in registration with the drawing line.

198 – 203 Space Fruit: Still Lifes
Photographer: Andy Warhol
Stamped in black on verso © *Andy Warhol Enterprises, Inc. 1979.*
It bears the publisher's chopmark and Joe Grippi's chopmark. The prints numbered in Roman numerals have Joe Grippi's chopmark but no stamps or publisher's chopmark.
There is one unsigned and unnumbered progressive set for each print which includes the separate colors of the print progression plus one with only the drawing line and one with the black printer like the edition in registration with the drawing line. There are eight prints in the Peaches set, eight in Cantaloupe I, seven in Cantaloupe II, six in Pears, seven in Apples and eight in Watermelon.

204 – 209 Shadows I
Photographer: Andy Warhol
Stamped in black on verso © *Andy Warhol 1979.*
Shadows I is written in pencil on verso.
It bears the printer's chopmark.

210 – 215 Shadows II
Photographer: Andy Warhol
Stamped in black on verso © *Andy Warhol 1979.*
Shadows II is written in pencil on verso.
It bears the printer's chopmark.

216 – 221 Shadows III
Photographer: Andy Warhol
Stamped in black on verso © *Andy Warhol 1979.*
Shadows III is written in pencil on verso.
It bears the printer's chopmark.

222 – 223 Shadows IV
Photographer: Andy Warhol
Stamped in black on verso © *Andy Warhol 1979.*
Shadows IV is written in pencil on verso.
It bears the printer's chopmark.

224 – 225 Shadows V
Photographer: Andy Warhol
Stamped in black on verso © *Andy Warhol 1979*.
Shadows V is written in pencil on verso.
It bears the printer's chopmark.

226 – 235 Ten Portraits of Jews of the Twentieth Century
Photographic credits: Sigmund Freud by Max Halberstadt, Albert Einstein by Trude Fleischmann.
Stamped in black on verso *Ten Portraits of Jews of the Twentieth Century* © *Andy Warhol 1980* Publishers: *Ronald Feldman Fine Arts, New York; Jonathan A Editions, Tel Aviv.*
It bears the printer's chopmark.
There are paintings of these images.

236 Karen Kain
Photographer: Andy Warhol
Stamped in black on verso *H. P. Productions, Ltd.* © *Andy Warhol 1980*.
It bears the printer's chopmark.
There are paintings of this image.

237 Kimiko
Photographer: Andy Warhol
It bears the printer's chopmark.
There are paintings of this image.

238 Mildred Scheel
Photographer: Andy Warhol
Stamped in black on verso © *Andy Warhol 1980*.
It bears the printer's chopmark.
The image is printed on a half sheet of Arches with one edge machine-trimmed and the other edge deckled.

239 Mildred Scheel
Photographer: Andy Warhol
Stamped in black on verso © *Andy Warhol 1980*.
It bears the printer's chopmark.

240 Edward Kennedy
Photographer: Andy Warhol
Stamped in black on verso © *Andy Warhol 1980*.
It bears the printer's chopmark.

241 Edward Kennedy (Deluxe Edition)
Photographer: Andy Warhol
Stamped in black on verso © *Andy Warhol 1980*.
It bears the printer's chopmark.

242 – 244 Joseph Beuys
Stamped in black on verso © *Andy Warhol 1980*. Stamped in blue on verso *Beuys by Warhol Published by Verlag Schellmann & Klüser, Munich.*
State I has no blue stamp.
This is the first time Warhol used rayon flock in screenprints.
There are paintings of this image.

245 – 247 Joseph Beuys
Photographer: Andy Warhol
It bears the printer's chopmark and the publisher's chopmark.
There are paintings of this image.

248 – 252 Shoes (Deluxe Edition)
Photographer: Andy Warhol
Stamped in black on verso ©*Andy Warhol 1980*.
It bears the printer's chopmark and the paper maker's watermark and chopmark.

253 – 257 Shoes
Photographer: Andy Warhol
Stamped in red on verso © *Andy Warhol 1980*.
It bears the printer's chopmark and the paper maker's watermark and chopmark.
#253 and #254 of the edition were misprinted and had to be reprinted. There still exist approximately 80 of each unsigned and unnumbered.
There are paintings of this image.

258 – 267 Myths
Photographic credits: Dracula, Sean McKeon by Andy Warhol; Howdy Doody by Andy Warhol; Mammy, Sylvia Williams by Andy Warhol; Santa Claus, John Viggiano by Andy Warhol; The Shadow, Andy Warhol by Rupert Smith; The Star, photograph of Greta Garbo as Mata Hari by Clarence Sinclair Bull; The Witch, Margaret Hamilton by Andy Warhol; Uncle Sam, James Mahoney by Andy Warhol.
Stamped in black on verso © *Andy Warhol 1981*
Publisher: *Ronald Feldman Fine Arts, Inc. New York.*
Stamped in black on verso of Superman: © *D. C. Comics, Inc. 1981 This interpretation created by Andy Warhol is derived from an original version of Superman copyrighted by D. C. Comics.*
Stamped in black on verso of Mickey Mouse: *This interpretation created and copyrighted by Andy Warhol is derived from an original version of Mickey Mouse copyrighted by Walt Disney Productions, Inc.*
It bears the printer's chopmark.
There are paintings of these images.

268 Jane Fonda
Photographer: Andy Warhol
Stamped in red on verso © *Andy Warhol 1982*.
It bears the printer's chopmark.

269 Double Mickey Mouse
Stamped in black on verso © *Andy Warhol 1981*
Publisher: *Ronald Feldman Fine Arts. Inc. New York.*
This interpretation created and copyrighted by Andy Warhol is derived from an original version of Mickey Mouse copyrighted by Walt Disney Productions, Inc.
It bears the printer's chopmark.

270 – 273 Goethe
Stamped in red on verso © *Andy Warhol 1982*
Publisher: *Edition Schellmann & Klüser, München*
Denise René/Hans Mayer, Düsseldorf.
It bears the printer's chopmark.
This image is based on the painting *Goethe in der Römischen Campagna*, 1787–1788 by Johann Heinrich Wilhelm Tischbein in the collection of the Städel Museum, Frankfurt.
There are paintings of this image.

274 – 286 $1, $4, Quadrant $, $9
Stamped in red on verso © *Andy Warhol 1982*.
It bears the printer's chopmark.
The $ images are based on those found in newspaper advertisements.
There are $ paintings.

287 Eric Emerson (*Chelsea Girls*)
Based on a frame from Andy Warhol's 1966 film, *Chelsea Girls*.
Until the publication of this catalogue, this print had been incorrectly titled *Eric Anderson (Chelsea Girls)*.
Artists in *A Portfolio of Thirteen Prints*: Abraham, Andre, Baranik, Beuys, Neel, Oldenburg, Rauschenberg, Rosenquist, Serra, Harry Smith, Stevens, Warhol, Wegman.
It bears the paper maker's watermark.

289 Committee 2000
Stamped in red on verso © *Andy Warhol 1982*.
It bears the printer's chopmark.
One print says *OK to print* signed Andy Warhol.
There are paintings of this image.

290 Brooklyn Bridge
Based on a photograph in the collection of the Museum of the City of New York.
Stamped in red on verso © *Andy Warhol 1982*.
It bears the printer's chopmark.
There is an unsigned edition of posters using this image.

291 – 292 Alexander the Great
Stamped in red on verso © *Andy Warhol 1982*.
It bears the printer's chopmark.
There are paintings of this image.

293 – 302 Endangered Species
Photographic credits: African Elephant, Mitch Reardon; Bald Eagle, George Galicz; Bighorn Ram, S. J. Krasemann; Black Rhinoceros, Mohammed Amin; Giant Panda, George Holton; Grevy's Zebra, Mohamed Ismail; Orangutan, Jerry Ferrara; Pine Barrens Tree Frog, George Porter; San Francisco Silverspot, Larry Orsak; Siberian Tiger, Tom McHugh. Special thanks to Photo Researchers, Inc., New York for making its archives available.
Stamped in red on verso © *Andy Warhol 1983*.
Publisher Ronald Feldman Fine Arts, Inc., New York.
It bears the printer's chopmark.
There are paintings of these images.

303 Speed Skater
Stamped in red on verso © *Andy Warhol 1983*.
It bears the printer's chopmark.
Artists in the *Art and Sports* portfolio: Dorazio, Folon, Greco, Helnwein, Hodgkin, Hozo, Hwang, Kolář, Moore, Paladino, Pistoletto, Santomaso, Stupica, Rosenquist, Twombly, Vasarely, Warhol.
All artists except Warhol numbered the regular edition in Arabic numerals and the Deluxe edition in Roman numerals.
There is an unsigned, unlimited edition of posters using this image.

304 Sidewalk
Photographer: Andy Warhol
Stamped in red on verso © *Andy Warhol 1983*.
It bears the printer's chopmark.
Artists in the *Eight by Eight...* portfolio: Diebenkorn, Francis, Hockney, Kelly, Rauschenberg, Saint-Phalle, Tinquely, Warhol. Box and frontispiece designed by Kosuth.
The movie stars' signatures, foot and hand prints are as they appear at Grauman's Chinese Theater in Hollywood (now called Mann's Chinese Theater).
For the first time since the *Hammer and Sickle* screenprints in 1977, there is no half-tone used in this screenprint.

305 Grace Kelly
Based on a movie still from *Twentieth Century*.
Stamped in black on verso © *Andy Warhol 1984*
Institute of Contemporary Art, University of Pennsylvania, with the consent of the Princess Grace Foundation, U.S.A.

306 Wayne Gretsky #99
Photographer: Andy Warhol
Wayne Gretsky is a hockey player for the Edmonton Oilers.
There are paintings of this image.

307 – 309 Kiku
Photographer: Andy Warhol
Stamped in blue on verso © *Andy Warhol 1983*.
They bear the publisher's chopmark, the Japanese printer's chopmark and the paper maker's watermark.
The chrysanthemum is the insignia of the Royal House of Japan.

310 – 312 Love
Photographer: Andy Warhol
Stamped in blue on verso © *Andy Warhol 1983*.
They bear the Japanese printer's chopmark and the paper maker's watermark.

313 – 315 Ingrid Bergman
#313 based on an early publicity photograph, #314 based on a movie still from *The Bells of St. Mary's* and #315 based on a movie still from *Casablanca*.
Stamped in blue on verso © *Andy Warhol 1983*
Publisher Galerie Börjeson, Sweden.
It bears the printer's chopmark.
There is a Guarantee of Authenticity sheet for each print, 11" x 8½" (27.9 x 20.9 cm), bearing the watermarked signatures of the artist, printer and publisher as well as the written signatures of all three.

316 – 319 Details of Renaissance Paintings
(Sandro Botticelli, *Birth of Venus*, 1482)
Stamped in red on verso © *Andy Warhol 1984*
Editions Schellmann & Klüser, Munich/New York.
The image is based on Sandro Botticelli's painting *Birth of Venus* in the collection of the Galeria Degli Ufizzi, Florence. The fourth image in the TP portfolios is based on Piero della Francesca's painting *Madonna del Duca da Montefeltro* in the collection of the Pinacoteca Museum, Brera.
There are paintings of this image.

320 – 323 Details of Renaissance Paintings
(Leonardo da Vinci, *The Annunciation*, 1472)
Stamped in red on verso © *Andy Warhol 1984*
Editions Schellmann & Klüser, Munich/New York.
The image is based on Leonardo da Vinci's painting *The Annunciation* in the collection of the Galeria Degli Ufizzi, Florence.
There are paintings of this image.

324 – 327 Details of Renaissance Paintings
(Paolo Uccello, *St. George and the Dragon*, 1460)
Stamped in red on verso © *Andy Warhol 1984*
Editions Schellmann & Klüser, Munich/New York.
The image is based on Paolo Uccello's painting *St. George and the Dragon* in the collection of the National Gallery, London.
There are paintings of this image.

328 Frederick Weisman
Photographer: Andy Warhol
There are paintings of this image.
This screenprint was commissioned by a private collector.

329 Viewpoint
It bears the printer's chopmark.
There is a painting of this image.

330 – 333 Saint Apollonia
Based on a painting on a panel, *Saint Apollonia*, 1470, attributed to an assistant of Piero della Francesca which is in the collection of the National Gallery in Washington, D.C.
Stamped in black on verso © *Andy Warhol 1984*.
There are paintings of this image.

334 – 349 Reigning Queens
Based on official or media photographs of Queen Elizabeth II of the United Kingdom, Queen Beatrix of The Netherlands, Queen Margrethe II of Denmark and Queen Ntombi Twala of Swaziland, the only four reigning queens at this date.
Stamped in black on verso © *Andy Warhol 1985*.
It bears the printer's chopmark.
There are paintings of these images.

350 – 359 Ads
Based on original advertisements for products or movies.
Stamped in black on verso © *Andy Warhol 1985*.
Publisher: Ronald Feldman Fine Arts, Inc., New York
The appropriate copyright information is stamped on verso of each image.
It bears the printer's chopmark.
There are paintings of these images.

360 Anniversary Donald Duck
Stamped in black on verso © *Andy Warhol 1985*
Publisher: Ronald Feldman Fine Arts, Inc. New York
This interpretation created and copyrighted by Andy Warhol is derived from an original version of DONALD DUCK copyrighted by Walt Disney Productions.
It bears the printer's chopmark.

361 – 364 Cologne Cathedral
Photographer: Andy Warhol
Stamped in black on verso © *Andy Warhol 1985*.
Publisher: Hermann Wünsche, Bonn-New York
It bears the printer's chopmark.
There are paintings of this image.

Index of Titles

Photographic Credits: All the color photographs in this catalogue were taken by D. James Dee with the following exceptions: #1, (#3 Joseph Szaszfai), #6, #13, #14, #15, #19, #20, #22–31, #120, #121, (#122 and #123 F. J. Thomas), #126, #127, #155, #237, #238. We are grateful to the Colorado State University Department of Art, Gendai Hanga Center, Wadsworth Atheneum and Frederick Weisman for lending us transparencies.

The black and white photographs were taken by the following photographers: p. 7 Carol Kaliff; p. 12 Jörg Schellmann; p. 13 Barbara Goldner except center left Christopher Makos, bottom left Deborah Dulman; pp. 22–23 Peggy Jarrell Kaplan; p. 24 Carol Kaliff; p. 120 Peggy Jarrell Kaplan

We would like to thank Castelli Graphics, Inc., Rosa Esman, Ivan Karp, Billy Klüver, Julie Martin, Multiples, Inc., Walasse Ting, Annabelle Weiner and David Whitney for generously providing prints to be photographed for this catalogue. Very special thanks to Andy Warhol and Rupert Jasen Smith for making their collections available to be photographed.

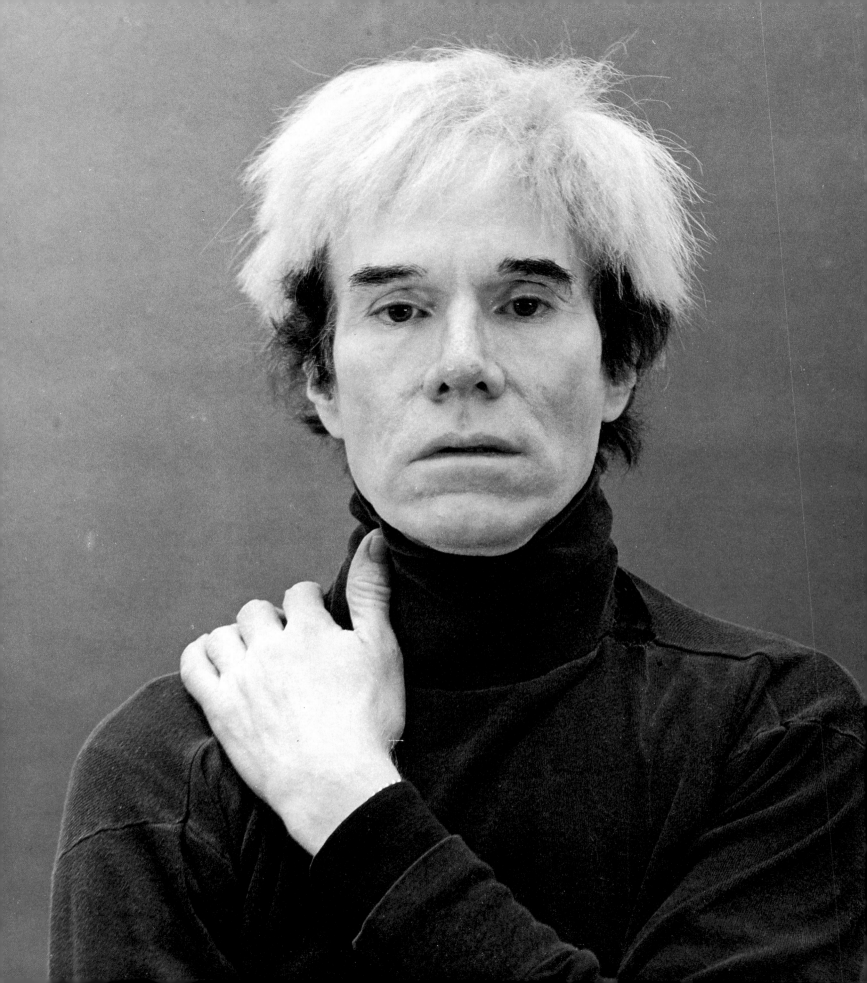